Contents

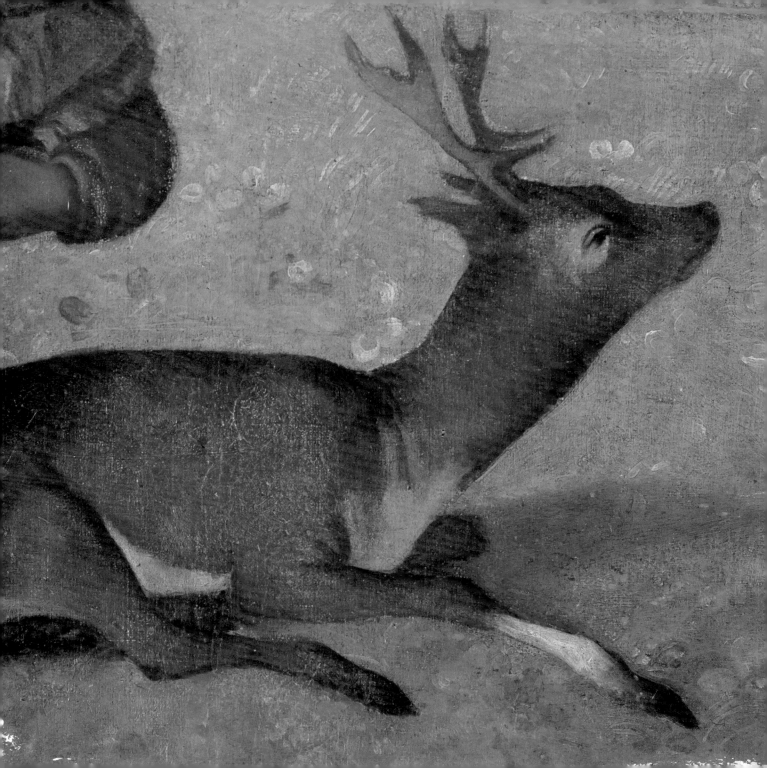

Titian
A fresh look at nature

Antonio Mazzotta

National Gallery Company, London

Distributed by Yale University Press

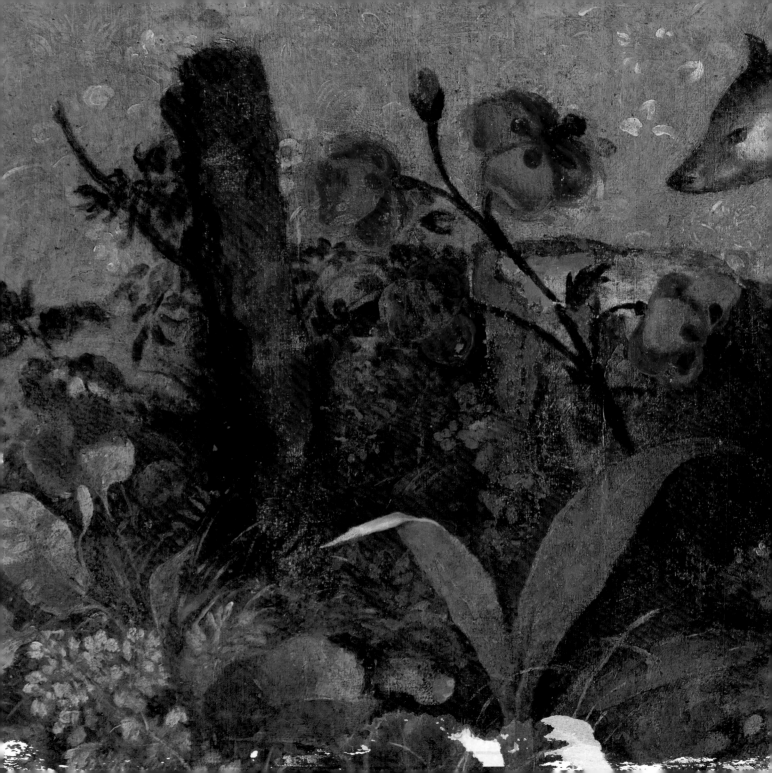

Director's foreword

The revolutionary achievement of the young Titian was made possible by his interaction with four great artists at the start of his career. Schooled by Giovanni Bellini, he associated with Giorgione, competed with Sebastiano del Piombo, and came into early contact with the work of Dürer. In this book, Antonio Mazzotta provides a fresh view of this brief and extraordinary episode in the history of art, focusing on Titian's great *Flight into Egypt* from the State Hermitage Museum and on related paintings in the National Gallery.

The diplomacy and generosity of Mikhail Pietrovsky, director of the Russian State Museum in the Hermitage, have ensured that many of the recent discoveries made in his institution have been shared with an international public. We are honoured that the *Flight into Egypt*, after long neglect by art historians and over a dozen years of restoration, is shown in the exhibition *Titian's First Masterpiece: The Flight into Egypt*, alongside works from our collection explaining its genesis and confirming its attribution.

We are above all grateful to Irina Artemieva, curator of Venetian paintings in the Hermitage, for the idea of this exhibition: she has changed our understanding of Titian's debut as an artist. Antonio Mazzotta has, in addition to writing this book, acted as guest curator, assisted by Carol Plazzotta.

This book has been made possible by a donation made through the American Friends of the National Gallery by Neil L. Rudenstine and Angelica Zander Rudenstine, fervent champions both of what museums owe to scholars and of how they must be encouraged to reach a larger public. We are also indebted to the National Trust (Ickworth), the Most Hon. the Marquess of Bath and His Grace the Duke of Northumberland, who have all lent paintings by Titian; to Lord Faringdon for his Sebastiano del Piombo, and to the Trustees of the British Museum and Hugo Chapman (Keeper of the Department of Prints and Drawings) for their generous loans to the exhibition.

Nicholas Penny
Director, The National Gallery

Introduction

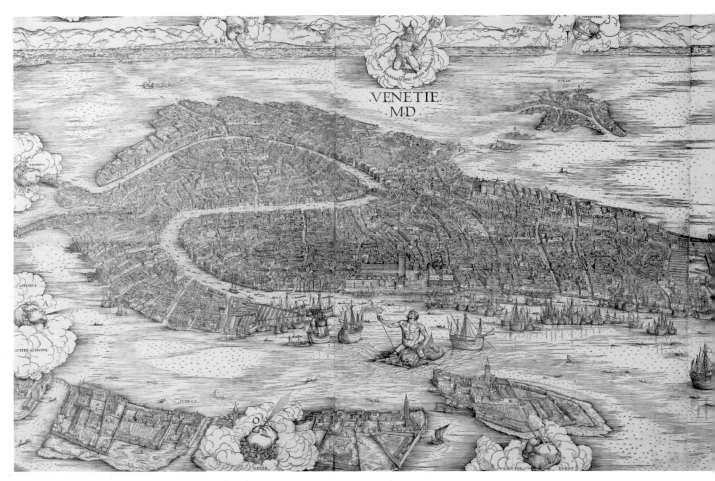

Fig. 1
Jacopo de' Barbari, *Bird's-eye View of Venice*, 1500, The British Museum, London

When the young Titian (Tiziano Vecellio), who was born in about 1488–90, first arrived in Venice, Jacopo de' Barbari was designing his ambitious bird's-eye view of the city (fig. 1), circulated to great acclaim as a print in 1500. This shows us Venice at the height of its brilliance, but in shape and form more or less as it is today. In the background, high on the horizon, are the same Alps where Titian was born and grew up. For a gifted young artist, brimming with life and energy as he must have been, there can have been no more stimulating environment in the world.

These were, however, turbulent times in Venice, both militarily and politically. A radical revolution in Italian art was also underway, not least in the creative melting pot of Venice. And like most revolutions, it ran its course in about fifteen years: from the end of the fifteenth century to just before 1515, the period that we will be looking at here. The most powerfully representative figure of these crucial years in Venice is undoubtedly Leonardo Loredan, Doge (elected ruler of the Republic of Venice) from 1501 to 1521, whose serenity and strength shine forth from Giovanni Bellini's iconic portrait (fig. 2).

It is most likely that, in his very early teens, Titian received his training with Giovanni Bellini; he would thus have had the opportunity to meet other gifted young painters who, sooner or later, were drawn to the studio of the patriarch of Venetian painting. They included Giorgione and Sebastiano Luciani (later to acquire the title 'del Piombo' in Rome). We shall see how Titian was able to familiarise himself with the art of Northern Europe, in particular with that of Albrecht Dürer who was in Venice between 1505 and the beginning of 1507, and who paid a visit to Bellini in 1506.

The main focus of this book is an astonishing painting which embodies the essence of Titian's youthful training. This is the *Flight into Egypt*, now in the Hermitage in St Petersburg (fig. 58): one of Titian's earliest works and certainly his first complete masterpiece on a large scale. The painting depicts the biblical story (Matthew 2:13–23) of the flight of the Holy Family into Egypt to save their Son from the massacre of newborn boys ordered by King Herod. The subject of this work was extremely unusual in Venetian paintings of the previous century; in it, Titian displays a new, all-embracing vision of nature and mankind, and of the interplay between the two. I shall attempt to distil from this painting the influences of Titian's contemporaries, and to understand its relationship with key works by Titian himself.

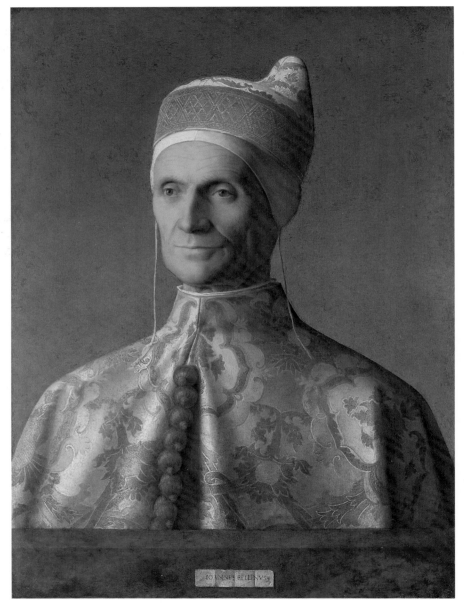

Fig. 2
Giovanni Bellini, *Doge Leonardo Loredan*, about 1501–2, The National Gallery, London

This book is divided into two chapters; the first spotlights the people who helped set the young Titian on the road to success, including the influential patrons who commissioned work from him. By studying them, we can visualise the birth of Titian's paintings through their eyes and are better placed to understand the artistic ideas to which the young painter responded, as well as to reflect on the originality of his portraiture.

In the second chapter I shall explain the visual experiences upon which the youthful artist drew, and to imagine how he was able to conceive and then to express through painting such an innovative and astonishing interpretation of nature. We shall also discover what spark ignited Titian's creations: his human subjects, his animals and plants – even his flowing streams and rivers. Although the *Flight into Egypt* was not in the true sense a landscape painting, much of it is devoted to the natural world, and we understand some of its originality better by looking at other contemporary works in the National Gallery and from elsewhere.

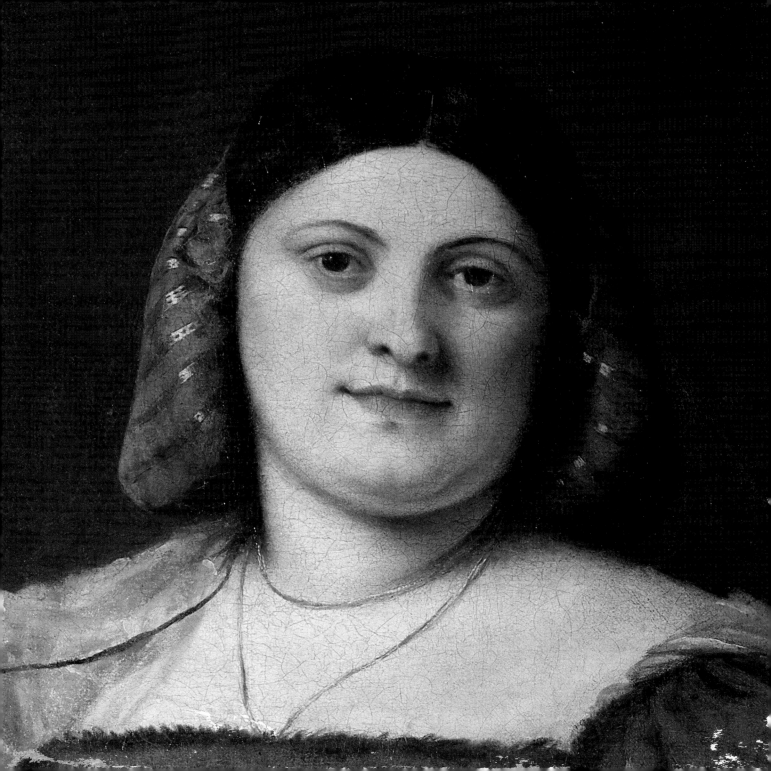

Titian's first patrons and their appearance

The *Flight into Egypt* was almost certainly commissioned by Andrea Loredan, a distant relative of Doge Leonardo, for his new palace on the Grand Canal (now known as Ca' Loredan-Vendramin-Calergi, fig. 3); the palace was designed by Mauro Codussi and completed by 1509, after the architect's death in 1504.

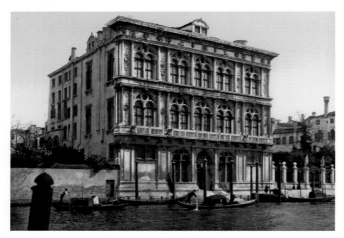

Fig. 3
Ca' Loredan-Vendramin-Calergi, Venice, photographed at the end of the nineteenth century

This remarkable building, one of the earliest examples of mature Renaissance architecture to adorn the Grand Canal, owes its fame in part to the fact that the composer Richard Wagner died there in 1883. Today it houses the Casino of Venice.

We know for certain that the great painting in the Hermitage came from this palace: it was regularly described as hanging there until the mid-eighteenth century when it was acquired by Heinrich von Brühl, the great German collector who probably displayed it in Dresden with the rest of his collection. In 1768, Brühl's heirs sold it with most of the rest of the collection to Catherine the Great, Empress of Russia. The first description of the work could however be taken as confirmation of its provenance; the description dates from about two hundred years before it left Venice and specifies the location in which it hung. In his *Life of Titian*, which appeared in the revised and enlarged second edition of his *Lives of the Artists* in 1568, Giorgio Vasari describes this painting at some length:

'... he painted a large picture with figures nearly the size of life, which is now in the hall of Andrea Loredan, who dwells near S. Marcuola. In that picture is painted Our Lady going into Egypt, in the midst of a great forest and some views of the countryside that are very well done, because Titian devoted many months to the study of such things, and had kept in his

house for that purpose some Germans who were excellent painters of landscape scenery and plants. In the wood in that picture, likewise, he painted many animals, which he portrayed from the life; and they are truly natural and almost alive.'

As well as telling us where the painting was hung, Vasari also provides some valuable critical views about it, which are examined in some detail later in this book.

We can attempt to locate the origins of the *Flight into Egypt* within a narrow circle of patronage. Many of Titian's earliest patrons have a name but no face. With others, we know their faces but not their names. In a very few cases we know both. The painting formerly known as *Man with a Quilted Sleeve* in the National Gallery (fig. 5) is an exceptional case, and can in all probability be identified as a portrait described by Vasari (as it happens, on the same page of his *Life* as the *Flight into Egypt*):

> 'At the time when he first began to follow the manner of Giorgione, not being more than eighteen years of age, he made the portrait of a gentleman of the Barbarigo family, his friend, which was held to be very beautiful, the likeness of the flesh colouring being very natural, and all the hairs so well distinguished one from another, that they might have been counted, as also might have been the stitches in a doublet of silvered satin that he painted in that work. In short, it was held to be so well done, and with such diligence, that if Titian had not written his name in shadowed letters (*'in ombra'*), it would have been taken for the work of Giorgione'.

An old copy of the National Gallery's portrait in a private collection is inscribed with a reference to the aristocratic Barbarigo family; moreover, Vasari's praise for the 'doublet of silvered satin' surely confirms that this was the painting Vasari describes. A member of the Barbarigo family was therefore, together with Andrea Loredan, one of the first people to launch the young Titian. The most likely subject of the celebrated portrait in the National Gallery is Gerolamo di Andrea Barbarigo. Gerolamo must have known Andrea Loredan, since on 1 August 1509 both were appointed for two of the most important public bodies in the Venetian Republic, respectively the Capi dei Quaranta and the Consiglio dei Dieci. Loredan and Barbarigo were both highly cultivated

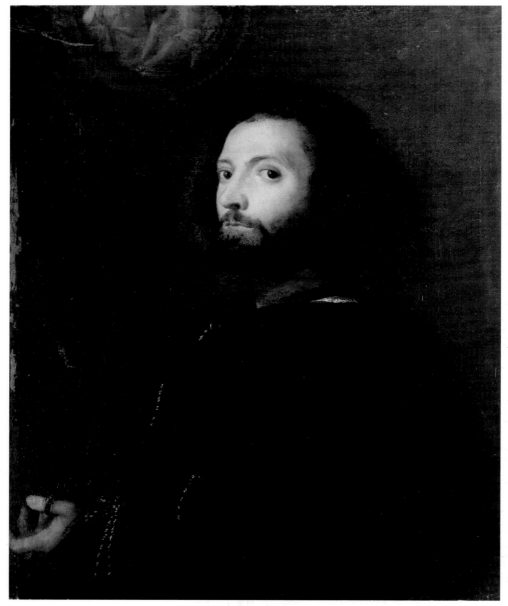

Fig. 4
Titian, *Portrait of a Man*, about 1507–8, The Bristol Collection, Ickworth, Suffolk

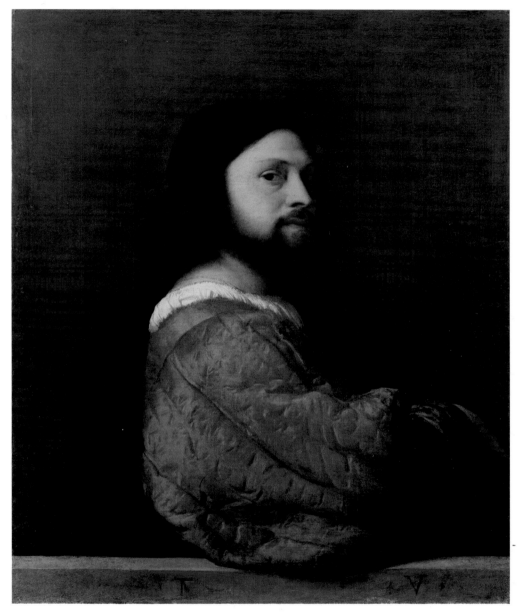

Fig. 5
Titian, *Portrait of Gerolamo (?) Barbarigo*, about 1509, The National Gallery, London

men and were, most probably, also in touch with the latest literary developments, including the work of Pietro Bembo, who years later was painted by Titian (and in a somewhat later correspondence reveals that he was acquainted with Gerolamo). Titian's youthful creative energy was stimulated by such patrons, whose sophisticated tastes soon encouraged the inexperienced young artist to excel and to be innovative; we need only compare his early portraits, with their extraordinary immediacy and human warmth (see figs 4–6, 14) with Bellini's *Doge Leonardo Loredan* (fig. 2). To the young Titian this must already have seemed like an icon from a vanished world.

The *Portrait of Gerolamo (?) Barbarigo* amazes by the sheer power of the pose, and by all that this expresses: we are in the presence of a man who knows no fear and who is conscious of living at the centre of the world – in Venice. Such calm self-confidence may never have been depicted in a portrait before. Although Titian, according to Vasari, was no 'more than eighteen years old' when he painted the portrait (he may have been a couple of years older) it is not the earliest evidence we have of his precocious talent as a portrait painter. In fact a portrait exists whose style suggests that it preceded (even if only by a short time) the *Portrait of Gerolamo (?) Barbarigo*: this is the *Portrait of a Man* at Ickworth (fig. 4). In the absence of a firm identification of the sitter, the Titian scholar Harold Wethey found the perfect description for this fascinating (though very damaged) painting: the 'Gentleman with Flashing Eyes'. His eyes, like those of Barbarigo, are fixed like spotlights on the spectator, staring at us with unashamed candour. I should like to think that these same eyes rested on the *Flight into Egypt* and were filled with the admiration we still feel today. The sitter's sideways pose only serves to heighten the penetrating effect of the gaze.

At first sight, these portraits give us the same sense of curiosity and disquiet that we experience when a stranger turns towards us and our eyes suddenly meet. The Ickworth portrait also contains a semi-circle with a *bas-relief* at the upper left, an interesting addition in respect of its composition (the same geometric motif characterises other portraits of the period, such as Giorgione's *Portrait of a Man* in Alte Pinakothek, Munich). Titian used similar *bas-reliefs* in other early works: the legs of the seated female figure, just visible, are similar to those of the figures in the classical frieze beneath the throne of Saint Peter in *Jacopo Pesaro being presented by Pope Alexander VI to Saint Peter*, a work by Titian that may have been executed at the same time (Koninklijk Museum voor

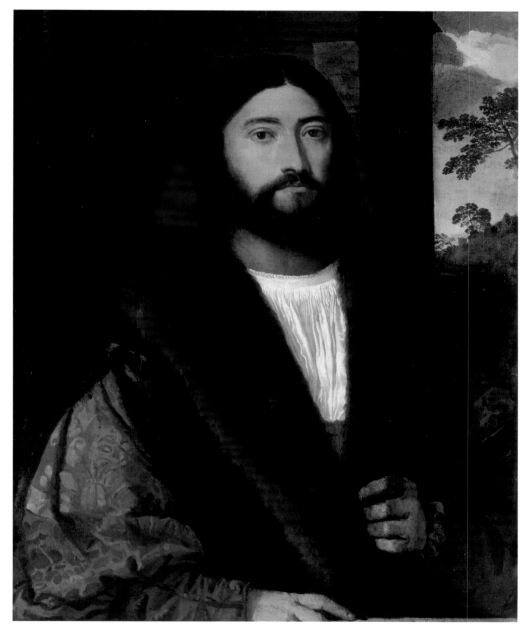

Fig. 6
Titian, *Portrait of a Man (a Barbarigo?)*, about 1512–4, Collection of the Duke of Northumberland, Alnwick Castle

Fig. 7
Titian (detail of fig. 6)

Schone Kunsten, Antwerp). The Ickworth Man could be assumed to be earlier than the National Gallery Barbarigo on formal grounds, although both are set in the 'modern' way, looking over their shoulder towards us. But Barbarigo's pose is more dynamic, and his great sleeve shows a more mature skill in the handling of space. We know that Titian executed a large-scale fresco, probably in 1509, for the Fondaco dei Tedeschi, one of the largest buildings on the Grand Canal. This commission, unfortunately reduced today to a few fragments detached from the walls, may have been promoted by Barbarigo himself (as Vasari tells us), and demonstrates just how successful Titian had become in the space of a few years: his innate heroic style was well suited to a Venice on the

edge of the abyss. This was the period when the League of Cambrai was formed – when almost all the European powers banded together against Venice. As we shall see, disasters loomed which would threaten the Republic's very existence.

It is hard to believe that the two men portrayed by Titian did not know each other. The circle within which the painter grew up – he became almost at once the darling of the Venetian aristocracy – was very narrow. The bearded character in the *Portrait of a Man (a Barbarigo?)* in Alnwick Castle (fig. 6) must surely have belonged to this same milieu. In the nineteenth century the sitter was believed to be the Barbarigo described by Vasari, given the presence of a blue sleeve of silvered satin which so vividly recalls the 'doublet of silvered satin'. Oddly enough, it has also been suggested – aside from the Barbarigo question – that this could represent the same person as in the National Gallery portrait. The colour of the eyes (blue in the first, brown in the second) makes this hypothesis untenable, but there is nothing to prevent anyone thinking that they could be related. Barbarigo or not, it is a superb portrait, although not all experts have accepted it as an undisputed work by Titian. It belongs to the genre of frontal portraits '*in maestà*' (in majesty) (a term used in the sixteenth century by two important sources, the 'connoisseur' Marcantonio Michiel and Ludovico Dolce). The face (fig. 7), with its quick, confident touches of light on nose, eyes and cheek, is a virtuoso piece of work.

Although formally quite conservative, the Alnwick portrait was definitely painted after *Gerolamo (?) Barbarigo*. In fact Titian was less daring at this later date; his aim was to set a standard for portraiture as a genre, and he experimented with this in the *Portrait of a Lady ('La Schiavona')* in the National Gallery (fig. 14). The architectural detail and glowing landscape, which seems intended to raise the emotional temperature of the person portrayed, render the composition even more sophisticated.

A travelling companion:
Sebastiano del Piombo

The *Flight into Egypt* (fig. 58) was probably destined for the *portego* (the ground floor hall) of Andrea Loredan's palace (Vasari, who may have been unfamiliar with the Venetian word *portego*, refers to the *sala*). All the leading artists of the day seem to have contributed to this space: from the ageing Giovanni Bellini (with two great 'Cosmographies' or views of the known world), to Giorgione (who frescoed two niches with allegories of 'Diligence' and 'Prudence') and Sebastiano del Piombo.

Apart from the *Flight*, the only surviving painting in this scheme is very likely Sebastiano's enigmatic *Judgement of Solomon* at Kingston Lacy (fig. 8) which Michael Hirst has suggested was originally located in Andrea Loredan's palace along with Titian's painting; their dimensions are indeed very similar. This damaged but impressive canvas belongs more or less to the same period as Titian's painting, but artistically it is a more mature work. Sebastiano was about five years older than Titian; here he demonstrates a control of space, familiarity with the latest trends in Milan and Florence, and a sophisticated classical taste which the younger painter had not yet acquired.

A picture that has never been properly discussed is a *Head of a Girl* (fig. 10), hitherto held to be a copy (or an uninteresting version) of the 'real mother' in the *Judgement of Solomon* (figs 8 and 9). It possesses the gentle, seductive quality of Sebastiano's original work. The fact that this is not a copy is also confirmed by an obvious alteration to the iris of the right eye, which was originally in exactly the same position as the eye of the 'real mother'; this revision transforms the subject's gaze from focused to distracted.

Sebastiano surely wanted to depict the introspection of a young woman in love. The painting's format is derived from Giorgione's *Laura* (Kunsthistorisches Museum, Vienna; dated 1506 on the reverse) and belongs to an original Venetian genre: the so-called *belle* (beauties), idealised portraits of beloved women, sometimes inaccurately described as '*cortigiane*' (courtesans). These were frequently the subject of literary efforts by the devoted lover who commissioned the portrait, or by a poet of his acquaintance. The *Head of a Girl*

Fig. 8
Sebastiano del Piombo,
Judgement of Solomon, about
1506–7, Kingston Lacy, The Bankes
Collection (The National Trust)

is likely to have been painted by Sebastiano del Piombo while he was working for Andrea Loredan alongside his younger colleague Titian.

A painting by the young Titian which clearly belongs to the same genre is the *Bust of a Young Woman* now in the Norton Simon Museum in Pasadena (fig. 11). The 'Greek' shape of the nose, the striking plastic modelling of the cheek and the monumental quality of the neck would seem to reflect the influence of Sebastiano's *belle* painted at the same time. The handling of the paint, however, belongs entirely to Titian, the eyes and mouth indicated with quick strokes of pure colour. The disposition of the features, the form and the languid, evasive

Fig. 9
Sebastiano del Piombo (detail of fig. 8)

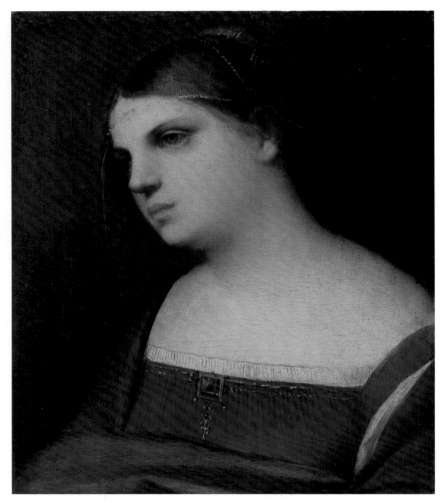

Fig. 10
Sebastiano del Piombo, *Head of a Girl*, about 1506–7, The Faringdon Collection Trust,
Buscot Park, Oxfordshire

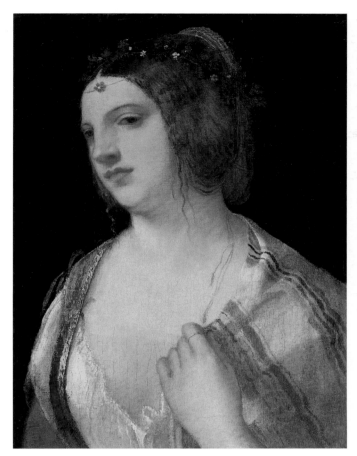

Fig. 11
Titian, *Bust of a Young Woman*, about 1507–8, The Norton Simon Foundation, Pasadena

Fig. 12
Titian (detail of fig. 58)

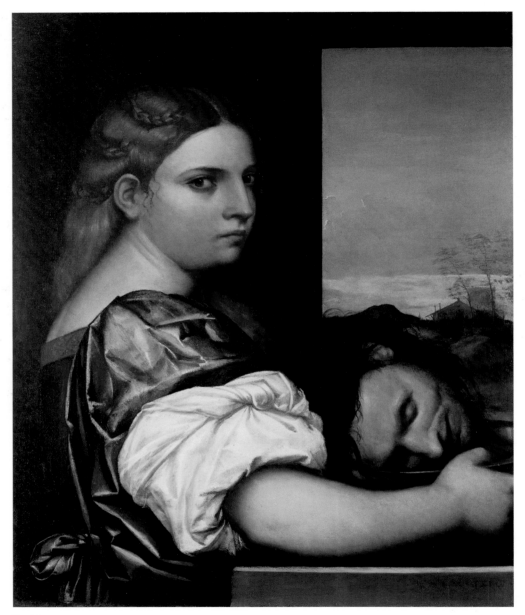

Fig. 13
Sebastiano del Piombo, *Salome*, 1510, The National Gallery, London

expression are reminiscent of the features of the Christ Child in the *Flight into Egypt* (fig. 12). Given that the two figures are so distinct in subject and purpose, the many pictorial similarities are both paradoxical and fascinating.

One painting by Sebastiano del Piombo in the National Gallery that fits neatly into this argument is his *Salome* (fig. 13), which bears the date 1510 on the parapet at the lower right. Her gaze conveys an intense energy that addresses us directly, unlike the distant expression of the girl from Buscot Park (fig. 10). The play of light on the face is similar in both paintings, as are the classical features, strangely echoing Athenian sculpture of the fifth century BC, in the high-bridged nose and the shape of the mouth. However, the plastic modelling and the power of Salome's face are much more developed, with the creases in the neck revealing its obvious twist. It is clear that Sebastiano was finally ready for the challenge of Rome, and by the following year had departed for that city.

Salome is important also because it gives us a sense of Sebastiano's relationship at this date with Titian, who, meanwhile, had achieved some noteworthy successes. Some of the formal features of Titian's *Gerolamo (?) Barbarigo* (fig. 5) seem to be reflected here, such as the twist of the upper body in the opposite direction to the head and the physical presence of the right arm, almost intruding into our space. Titian's skill in suggesting bodily form projecting from the canvas may, in this case, have influenced his more experienced colleague.

Reaching maturity in portraiture: *'La Schiavona'*

We conclude this group of faces with the first of Titian's truly mature portraits: the National Gallery's so-called *'La Schiavona'* (literally, 'The Woman from Slavonia'; the model is thought to have been of Dalmatian origin) (fig. 14). This portrait radiates contentment and self-confidence, and a remarkable power; the sitter has almost been elevated to the status of Roman matron! When the painting was in the Crespi collection in Milan in the early twentieth century it was hung at the end of a long series of doors, to give the impression of the lady of the house welcoming guests, while jealously guarding her property. The figure fills the surrounding space with total confidence. Any timidity such as might be found in the work of Giorgione has vanished; here Titian reaches a standard so high that he could maintain but never surpass it. This signals the beginning of a mature classicism that culminates in such great achievements as *Bacchus and Ariadne* in the National Gallery. The *'Schiavona'* provides a perfect parallel with the frescoes executed by Titian between late 1510 and 1511 in the Scuola del Santo in Padua. There are a number of other 'matrons' portrayed here, particularly on the right side of the *Miracle of the Speaking Infant*. It has often been remarked that, with the *'Schiavona'*, Titian intended deliberately to exalt painting above other arts: by including the sculpted *bas-relief* on the parapet, he seems to proclaim: 'This is painting, mother of all the arts!'

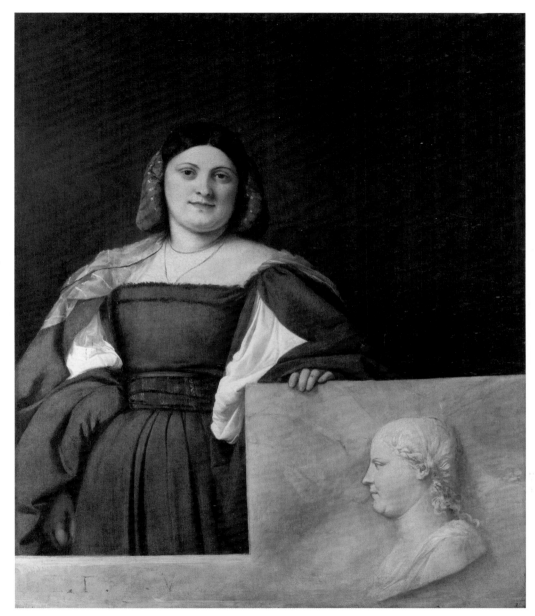

Fig. 14
Titian, *Portrait of a Lady ('La Schiavona')*, about 1511, The National Gallery, London

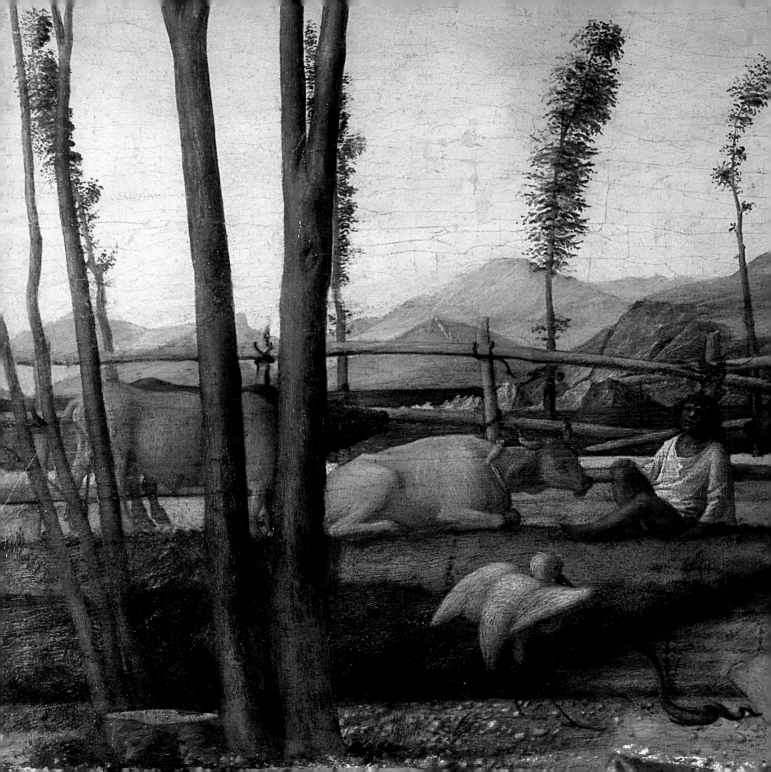

A fresh look at nature:
the *Flight into Egypt*

Fig. 15
Giovanni Bellini, *The Agony in the Garden*, about 1458–60, The National Gallery, London

'Titian, to whom Nature has imparted her secrets, the Homer of landscape painters. His views are so lifelike, so varied, so fresh, they invite you to take a walk in them.' Thus in 1762 wrote Francesco Algarotti, a friend of Heinrich von Brühl, who then owned the *Flight into Egypt*. In the mid-eighteenth century, when landscape painting had become a common genre in its own right, Titian's vision of nature was still perceived as 'modern' and his landscapes (although never the main subject) somehow realistic and 'true'.

As we shall see, the unique quality of Titian's landscape is the representation of nature as it evolves, of time passing, of humanity meekly submitting to the sacred

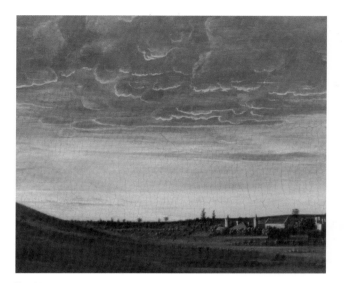

Fig. 16
Giovanni Bellini (detail of fig. 15)

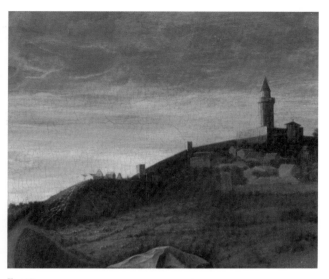

Fig. 17
Giovanni Bellini (detail of fig. 15)

laws that underpin everything. However, the roots of this modern, recognisable depiction of the natural world and of landscape can be traced to youthful works by Giovanni Bellini, the true patriarch and originator of Renaissance painting in Venice. One of the finest examples of his landscape painting is the background of *The Agony in the Garden* in the National Gallery (fig. 15).

In contrast to the anecdotal, overly 'close-up' approach to subjects of his father Jacopo's generation, Giovanni Bellini managed to distance himself and broaden the view, infusing his typical hilly landscapes of the Veneto with depth and coherence. The natural world depicted by Bellini in this wonderful painting is profoundly humanised: traces of man, including paths and walled towns perched on rocks are present but blended with the whole. Human beings are integrated harmoniously among natural features such as rocks, hills, rivers or trees. A feeling of peace pervades, and the artist's eye familiarises everything it sees before rendering it in paint. This is nature participating in the sacred event, a living, breathing force that extends beyond the confines of the pictorial space: for example, we sense the presence of the sun below the horizon through its effect on the clouds (fig. 16), or on the tower

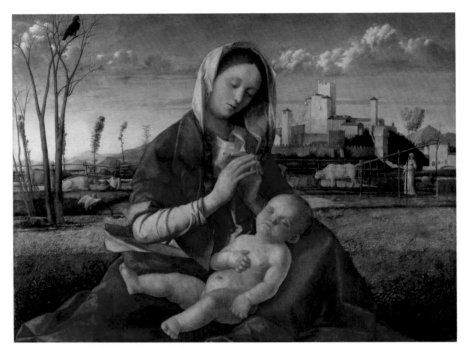

Fig. 18
Giovanni Bellini, *The Madonna of the Meadow*, about 1495–1500, The National Gallery, London

silhouetted at the top of the hill on the right (fig. 17). The tower, lit by the first rays of the rising sun, is the first to witness the renewed miracle of nature; nature is here almost the main subject of the painting, even if it still plays a role in the painting's religious significance. Although Bellini's pupils, from Giorgione to Titian himself, were less concerned with integrating sacred content in their poetic landscapes, they were still deeply indebted to Bellini's poetry of nature.

If we turn to Bellini's work in the years just before 1500, when the new generation of pupils in his studio were taking their first steps towards changing the course of Venetian art, we may begin to understand how the *Flight into Egypt* came into being. *The Madonna of the Meadow* in the National Gallery (fig. 18), dating from the very end of the fifteenth century, is one of the first Italian examples of a Madonna in a landscape devoid of the architectural

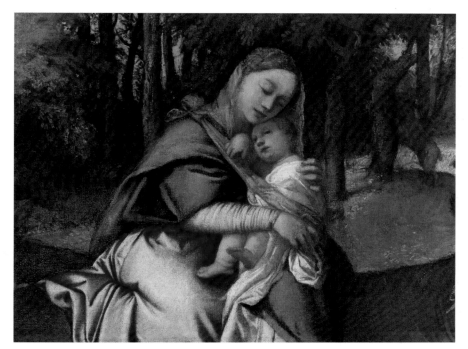

Fig. 19
Titian (detail of fig. 58)

elements and rich textile hangings typical of earlier Italian painting. The landscape is pervaded with lyrical incidents, including the melancholic shepherd and the ruminative cow beside him (detail of fig. 18, p. 28). It no longer lies above and beyond the holy figures, but completes them, playing an active part in the scene. Here the Mother and Child group in the foreground forms a pyramid, linked to the background and echoed on the right by the steep ascent to the hill town and the mountain.

When Titian came to paint the Virgin and Child on the donkey in the *Flight* (fig. 19), he seems to have been recalling the figure group in Bellini's painting: the position and tilt of the Virgin's oval face are very similar and form a comparable pyramidal structure. This stylistic relationship with Bellini's work is evidence of the early date of Titian's *Flight into Egypt*. Only a few years later, Titian would break decisively with the tradition of Bellini.

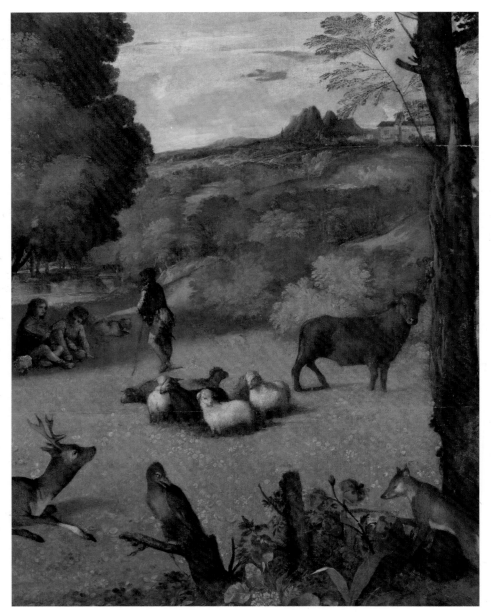

Fig. 20
Titian (detail of fig. 58)

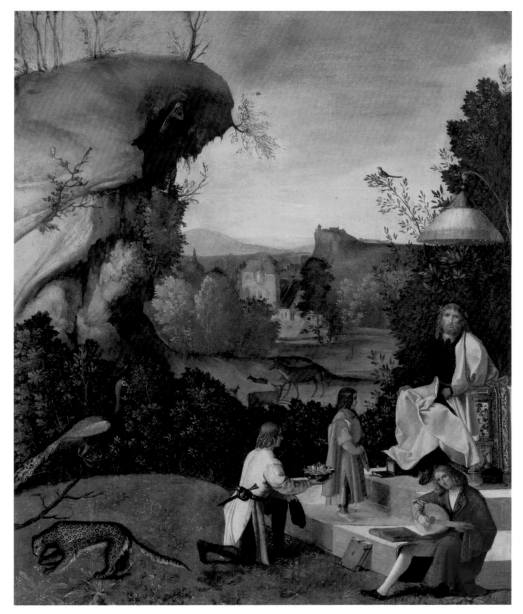

Fig. 21
Giorgione, or his circle, *Homage to a Poet*, about 1495–1500, The National Gallery, London

Giorgione's perspective

One of the most enigmatic paintings in the National Gallery is *Homage to a Poet* (fig. 21). The age-old question of whether or not it is by Giorgione will not be tackled here, nor will its true subject be investigated. What seems certain is that it is a late fifteenth-century Venetian painting, produced by an artist trained within Bellini's sphere of influence. It responds to the same artistic challenge as the *Flight*: the spatial reconciliation of human figures and animals within a landscape. Particularly in the right-hand section of the *Flight* (fig. 20) the basic premise is substantially the same, even though in the case of *Homage to a Poet* the spatial planes are more rigid, and the process of fusing the figures and the landscape still immature – and also still linked to a fifteenth-century system of geometrically organised space.

A fundamental difference between *Homage to a Poet* and the *Flight into Egypt* lies in the way the animals are represented. In the former painting the approach is connected to the late medieval tradition of the bestiary (texts describing and illustrating animals). The leopard and the peacock at the lower left (fig. 22) are two 'stuffed' animals, heraldic in appearance and certainly not painted from live models. They appear to be based on traditional model book drawings, such as those made around 1400 in the circle of Giovannino de' Grassi in Milan, some of which are now in the British Museum. One page, representing two wolves (fig. 23), demonstrates that even at the end of the fifteenth century a young artist, faced with the problem of depicting animals, would have recourse to these much earlier sources instead of making the effort to study a living specimen.

How then can the radical break made by Titian in the representation of animals be explained? How, in the few years between the end of the fifteenth century and the beginning of the sixteenth, could painters have shifted from copying late gothic albums to direct observation of nature? According to Vasari, the

Fig. 22
Giorgione, or his circle (detail of fig. 21)

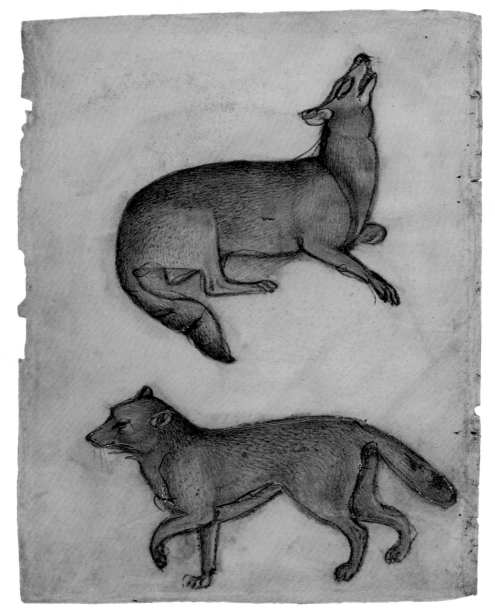

Fig. 23
Circle of Giovannino de' Grassi, *Two Wolves*, about 1400, The British Museum, London

'many animals, which he portrayed from the life ... are truly natural and almost alive'. However, in certain details even Titian seems to adopt an 'heraldic' model. One example of this is the wonderful deer in the *Flight* (fig. 24), whose body and hooves appear closely to resemble those in a print by Giulio Campagnola (fig. 25), an artist in Giorgione's sphere of influence. Campagnola was inspired by the personal device (*impresa*) on the back of a portrait by Jacometto Veneziano datable to about 1480 (Metropolitan Museum of Art, New York). Compared with the deer in Campagnola's print, however, Titian's, with its tense neck and muzzle outstretched as if to sniff the air, is touched by a miraculous breath of life, by a sympathy and feeling only equalled perhaps by Walt Disney's creations. We will shortly see what was the source of the vital spark that confers life on Titian's animals.

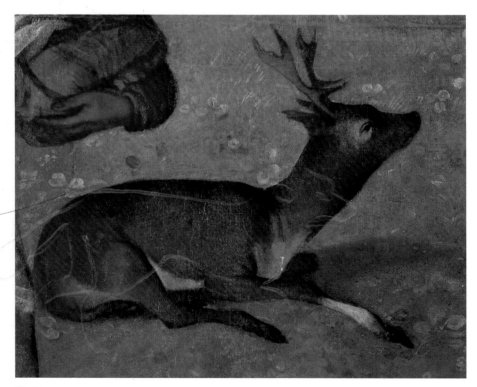

Fig. 24
Titian (detail of fig. 58)

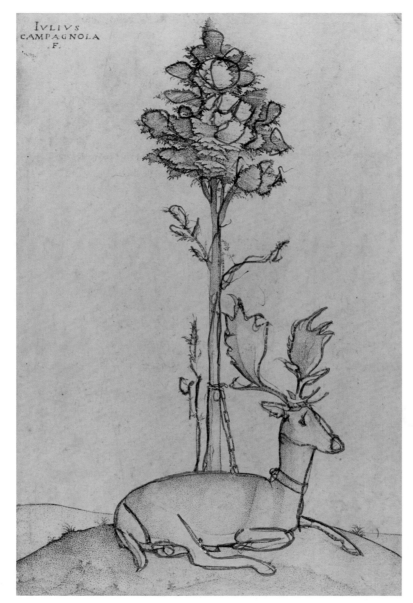

Fig. 25
Giulio Campagnola, *Stag at Rest chained to a Tree*, about 1505–10,
The British Museum, London

While the influence of Bellini is evident in the *Flight into Egypt*, that of Giorgione is present in equal measure. Giorgione's *Adoration of the Kings* (fig. 26) first came to the National Gallery as the work of Bellini. It is in fact one of Giorgione's earliest works, dating from the time when he was still working under the aegis of Bellini. The colour values in this small, delightful painting are worthy of Poussin: our eye scans the surface horizontally and is gratified by the transition from blue to orangey-yellow, to pink, green, red and back to yellow (canary yellow this time), and finally to white. The flowing drapery worn by the figures looks suddenly crisp, the pointed hems and springing folds have acquired, as we shall see, a 'German' shape. What relates this painting closely to Giorgione is the atmosphere of suspense, the apparent absence of any activity – although in reality this conceals a series of timid, silent movements that characterise each of the figures. Even the animals seem to be grave participants in holy contemplation. The lyrical feeling of some of the poses is more exaggerated, such as that of the figure on the right (fig. 27), leaning on a stick with his legs crossed. A similar pose can be found in the *Flight*: the soldier on the right with a sword and cuirass (fig. 28) seems hypnotised by the pastoral tranquillity in which he finds himself; he seems almost ready to give up making war.

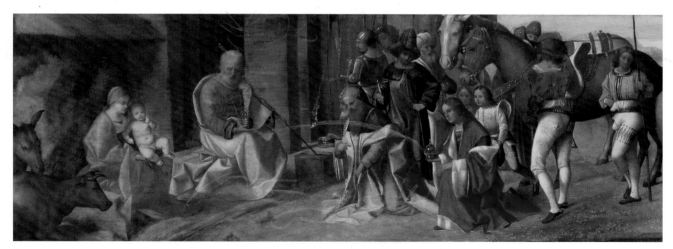

Fig. 26
Giorgione, *The Adoration of the Kings*, about 1498–1500, The National Gallery, London

A Virgin and Child (fig. 30) in the Hermitage appears to date soon after the *Adoration of the Magi*; it is of the same type as the *Madonna of the Meadow* (fig. 18) in the sense that the Virgin is again completely immersed in the landscape. This small masterpiece is almost certainly by Giorgione, the Virgin being comparable to her counterpart (similarly robed in red) in the altarpiece of the same date at Castelfranco. This picture – whose subject, though unusual in fifteenth-century Italy, was more common in Northern Europe – introduces a theme that will be discussed in more depth in relation to the *Flight into Egypt*: the relationship between Venetian and German art. It belongs in fact to a group of Giorgionesque works that the Austrian art historian Wilhelm Suida linked to the art of Martin Schongauer. There is for example a close relationship in composition, typology and colour scheme between the Hermitage painting and a Virgin and Child by a less-skilled follower of Schongauer in the National Gallery (fig. 29). Martin Schongauer became famous in Italy through his

Fig. 27
Giorgione (detail of fig. 26)

Fig. 28
Titian (detail of fig. 58)

engravings, among which are a number of prints based on a composition similar to this one; these were certainly in circulation in Venice at the end of the fifteenth century. From Schongauer, Giorgione borrowed the shape, and the angular folds of the robe, and also the colour. The Virgin's mantle in Italian art was traditionally blue; the choice of red for the robe in both paintings (figs 29 and 30) must also have been made because it plays better against its complementary colour green, omnipresent in pictures where vegetation plays such an important role. Giorgione evidently wished to pay further homage to this typically German genre of religious image by adding a glowing, carefully described flower in the right foreground.

This brings us to Venice in about 1500, around the time when the young Titian came to the city. The year is symbolic in various respects, most of all perhaps because of the presence in the city of a man who influenced some of the revolutionary artistic developments that were to follow, in particular in the work of Giorgione. At the beginning of 1500 Leonardo da Vinci, fleeing the devastating invasion of Milan by the French, sought refuge in Venice where his presence was to have far-reaching implications for the representation of the natural world and landscape. The seeds of his great

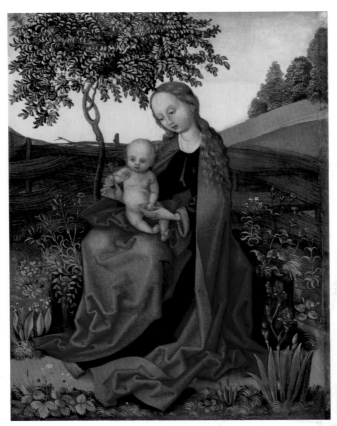

Fig. 29
Follower of Martin Schongauer, *The Virgin and Child in a Landscape*, about 1480–90, The National Gallery, London

erudition and his art were soon sown in the city and one of the first to nurture them and encourage them to flower was undoubtedly Giorgione, as Vasari also claimed. After 1500, Giorgione's view of nature and landscape, previously under the influence of Bellini with some German overtones, changed radically. In the wake of Leonardo, Giorgione began to focus on physical events and astronomical and meteorological phenomena. One drawing by Leonardo which may have awakened Giorgione's romantic sensibility is, for example, his *Storm in an Alpine Valley* (fig. 31), a masterpiece in red chalk which scholars have dated between the years of the *Last Supper* (to which it most convincingly belongs) and twenty years later. In this example, natural phenomena are the centre of attention. No-one had ever observed nature so objectively, nor transmitted the impression made on the retina with so admirably light a touch.

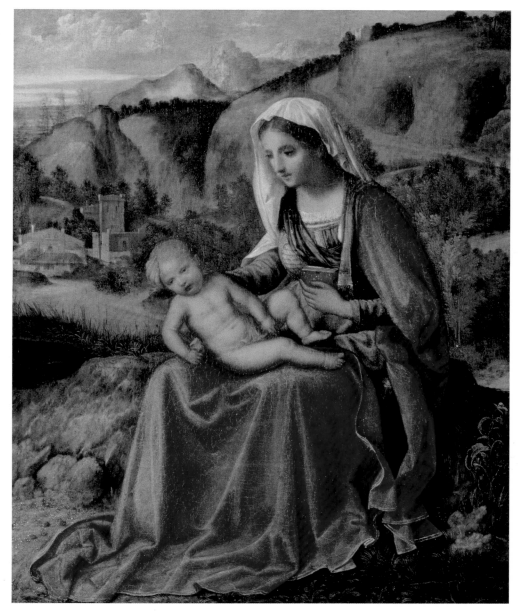

Fig. 30
Giorgione, *The Virgin and Child in a Landscape*, about 1500, The State Hermitage Museum, St Petersburg

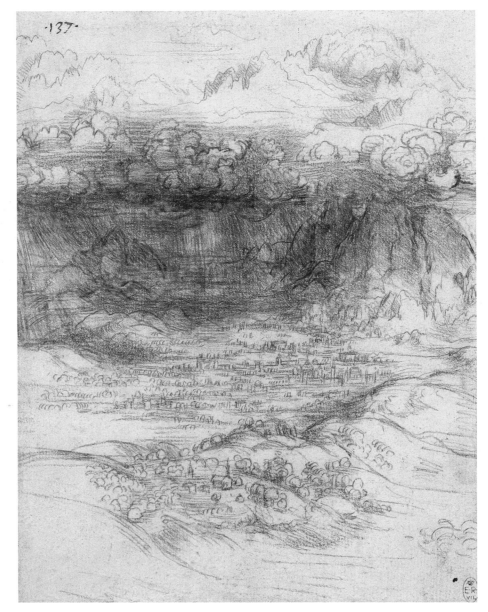

Fig. 31
Leonardo da Vinci, *A Storm in an Alpine Valley*, about 1495–7, The Royal Collection, Windsor

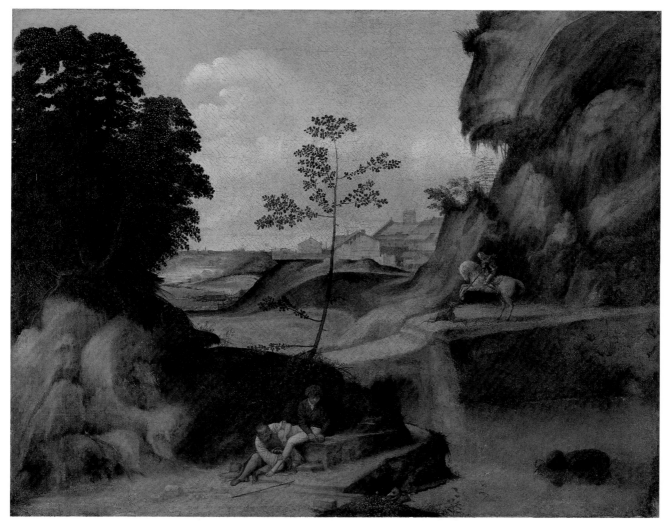

Fig. 32
Giorgione, *Il Tramonto (The Sunset)*, about 1501–2, The National Gallery, London

In this case Leonardo adopted the role of messenger, and nature (catastrophic nature in this instance) became art through the artist's observation of it. Giorgione followed a similar principle; his two paintings that best demonstrate this are the *Tempesta* (*The Tempest*) in the Gallerie dell'Accademia in Venice, and the *Tramonto* (*The Sunset*) in the National Gallery (fig. 32). The subject of the second painting, as much as the first, is still a matter of debate, and the various human elements, including Saint George killing the Dragon (in fact the result of a skilful but mystifying restoration), have been interpreted in a variety of ways. What is indisputable however, is that in this painting Giorgione concentrated on reproducing in paint the sense of awe aroused by natural phenomena, often of a very familiar nature.

We can imagine Giorgione's family and friends, during the summers spent in the countryside around Treviso, wondering what the young man was doing as he sat for hours on a rock, waiting for the sun to set, fixedly observing every variation of colour assumed by the darkening earth during the few minutes in which the daily miracle took place. The passing of time is indicated in the background of the *Tramonto* by a few light brushstrokes of white, denoting the rapid flow of water over the varying depths of the river (fig. 33) – a phenomenon that can be observed, for example, in the river Brenta. The same depiction of fast-flowing water is to be found in Titian's *Flight into Egypt* (fig. 34), but here it is not a river but an alpine stream, and the paint is applied quite thickly. Natural features have become pure painting. Titian's description is neither prosaic nor accurate: it is sensual.

Another feature linking Giorgione's *Tramonto* and Titian's *Flight* is the depiction of human beings fully integrated into the landscape, indifferent to what is taking place around them. In the foreground of the National Gallery painting are a youth and an old man (fig. 35). It is not clear what they are doing, but the position of their legs, arms and heads is echoed in the pose of the two shepherds (with a dog) seated under a tree in the *Flight* (fig. 36). Behind the two shepherds is a small, tranquil lake (not unlike that in the foreground of the *Tramonto*) reflecting everything that surrounds it, and transforming the environment into patches of colour.

The Hermitage possesses a small painting of the *Holy Family in a Landscape* (fig. 38) that undoubtedly has a flavour of Giorgione about it. The parents are

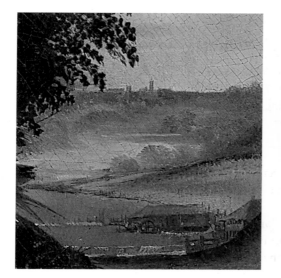

Fig. 33
Giorgione (detail of fig. 32)

Fig. 34
Titian (detail of fig. 58)

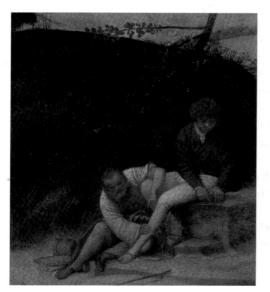

Fig. 35
Giorgione (detail of fig. 32)

Fig. 36
Titian (detail of fig. 58)

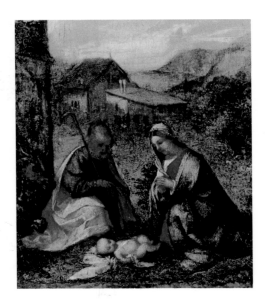

contemplating the infant Jesus, who appears to be the principal source of light – enough light to cause Saint Joseph's yellow mantle to glow. Above, spectral cherubs descend from a fiery globe in the sky to admire the Child. In the background are buildings that have the appearance of a Northern European print. Thanks to an engraving by the 'Master F. N.' dated 1515, which reproduces the composition very faithfully, we know that the painting must be earlier than that date. The same composition can be found in a panel painting now in the North Carolina Museum of Art in Raleigh (fig. 37). This is one of the earliest paintings ascribed by the majority of scholars to Titian and it is characterised by rapid, thickly painted brushstrokes similar to those employed in certain details in the *Flight into Egypt*. In a recent article on the *Flight*, the Hermitage's curator of Venetian paintings, Irina Artemieva, suggests that the Raleigh painting, with its close-knit composition and surface clotted with thickly applied paint, could be a sketch while the Hermitage painting might be the finished version. Whatever the truth of the matter, discussion of this composition is relevant here, since X-rays have recently revealed a similar Holy Family figure group beneath the surface of the *Flight*. For some reason, Titian changed his mind about the subject, and this had various implications for his representation of the natural world.

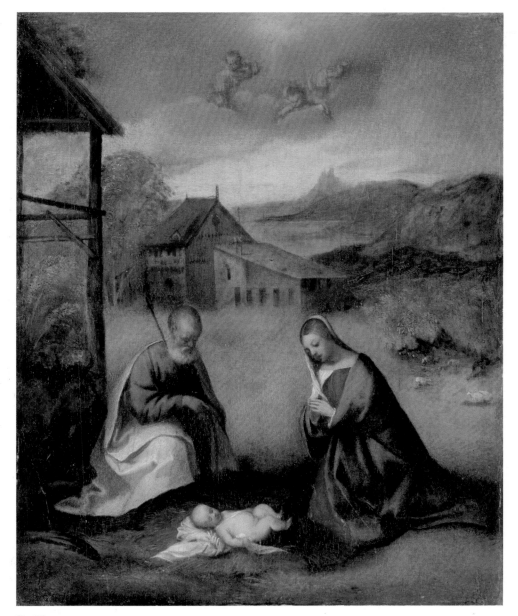

Fig. 38
Titian (?), *Holy Family in a Landscape*, about 1506 (?), The State Hermitage Museum, St Petersburg

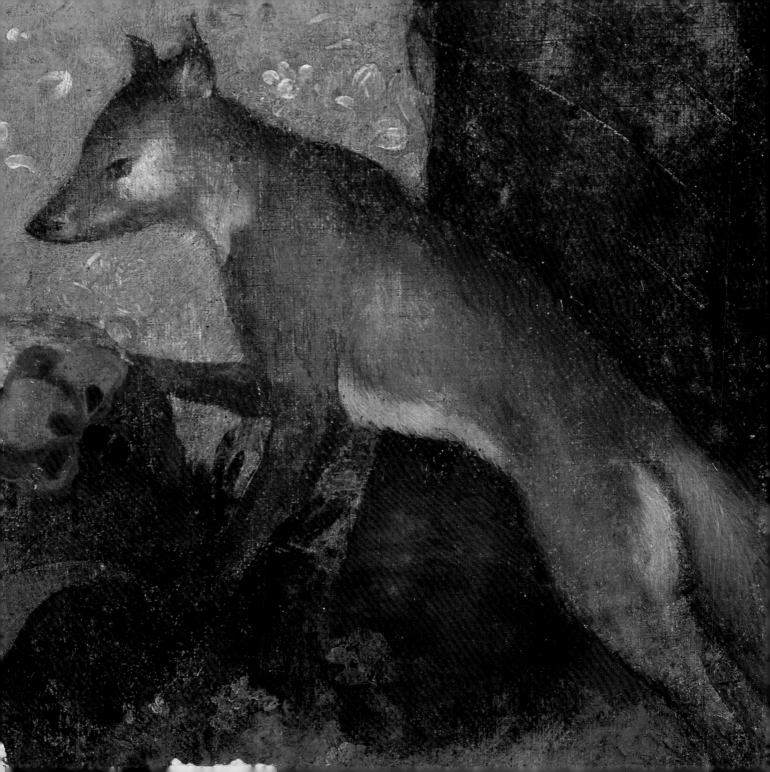

Life in the world of animals and plants: Albrecht Dürer

This change of subject made it possible for Titian to insert various species of animal, as if to make clear that the Holy Family's flight into Egypt was above all a journey made through the realms of nature. No longer hostile, nature has become a benign protagonist in the drama. One of the most striking aspects of the *Flight into Egypt* is the fact that the numerous animals are lifelike. It is not unreasonable to suppose that Titian, born and brought up in Cadore in the heart of the Dolomites, was more familiar with the animal kingdom than his friends from Venice or the Veneto. Who knows how many times as a child he had seen and touched such animals, stroking their backs and sensing their warmth? The fox at the lower right (fig. 39) can only be the outcome of direct observation: with its right paw propped against the tree trunk he stretches forward to see who is coming, ready to flee at the slightest hint of danger. To achieve this objective view, unfiltered by traditional models, Titian set out on a path that had only recently been signposted by another important artist, Albrecht Dürer.

The great painter, designer and printmaker from Nuremberg spent more than a year in Venice, from the end of 1505 to early 1507. On his first visit about ten years earlier he had been almost unknown. On his second, he was welcomed with respect and some sizeable commissions, including the altarpiece depicting the *Feast of the Rosary* for San Bartolomeo, the church of the German community in Venice (now in the Národní Galerie, Prague). The reality of his Venetian experience is summed up in a revealing passage of a letter written by Dürer on 7 February 1506 to his closest friend, Willibald Pirkheimer:

'I have many good Italian friends who counsel me not to eat or drink with their painters. Many of these are indeed my enemies and copy my work in churches, making it known wherever they can. Then they criticise it and say it is not in the 'ancient' style and is therefore no good. But Sambelling [Giovanni Bellini] praised me in the presence of a number of gentlemen. He would like to have something of mine and came himself to see me, begging me to do something for him, saying that he would pay me well. And everyone tells me that he is a devout man, so I am immediately well disposed towards him. He is very old and he is still the best at painting.'

Fig. 40
Albrecht Dürer, *Studies of a Hare*, about 1500–2, The British Museum, London

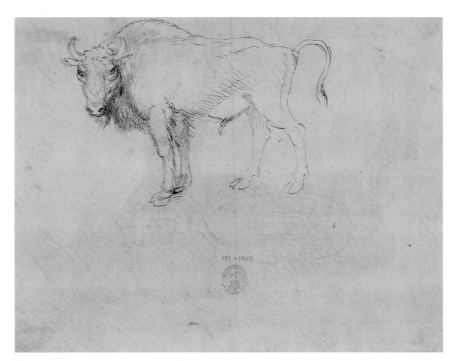

Fig. 41
Albrecht Dürer, *Study of a European Bison*, about 1501–4, The British Museum, London

Fig. 42
Titian (detail of fig. 58)

Dürer must have visited Bellini and probably gave him some of his work, presumably when Titian was already in the workshop, and perhaps just as he was beginning work on his first great masterpiece. From Vasari's description of the *Flight* ('a great forest and certain landscapes that are very well done, because Titian had devoted many months to the study of such things, and had kept in his house for that purpose some Germans who were excellent painters of landscape scenery and plants'), we may conclude that (even though it has been shown that by *'tedeschi'* – Germans – Vasari meant Northern Europeans in general) Titian and Giorgione must have been curious to see the work of this celebrated German artist: work that was so profoundly different from anything either had seen before. During his travels through the forests of Germany and then over the Alps, Dürer produced a multitude of pen and ink sketches from life. His observation of nature was so successful that when we see these pieces, including the *Studies of a Hare* and *Study of a European Bison* (figs 40, 41) we sense an immediacy and inherent life that had never been attempted before. These drawings capture the behaviour and characteristic movements of the animals as well as their form. In the *Studies of a Hare* (fig. 40), for example, a resting hare is drawn in different attitudes; below on the left, the hare with the wide open eye seems to be eating, while the one above on the right sniffs the

air. The *Study of a European Bison* (fig. 41) also reflects an accurate study of animal psychology: the back hooves are in motion, while the front hooves are still. The animal appears to have halted its step and raised its head in the direction of the spectator, whose presence evidently makes it anxious: 'Who's that over there and what does he want?' On the reverse of this pen and ink sketch is a more finished watercolour with nothing like the vitality of the first: it has been surmised that Dürer probably used a dead animal for this study. Titian's bull on the right-hand side of the *Flight* (fig. 42) strikes an attitude similar to that of Dürer's bison; the bull is surrounded by animals of various species, each with its characteristic traits. We have already come a long way from the cut-out figures of the medieval bestiary! In Aesop's *Fables* (so popular at that date) we find a similar sympathy with the behaviour of animals.

Another precisely observed animal in Titian's painting is the goat which characteristically clambers up a tree to eat its bark (fig. 43). Years later, Titian was to repeat the same motif in a pen and ink sketch, *Goats Feeding*, now in the Gabinetto dei Disegni at the Uffizi. Titian is able to capture the animal's movements simply using paint alone. It is no accident that, when he became famous, he chose as his *impresa* a she-bear giving form to its whelp by licking it (legend had it that the baby bear would otherwise have been shapeless), accompanied by the Latin motto *natura potentior ars* ('art is more powerful than nature'), to underline the role of the painter who uses his art to model the raw materials that nature provides.

Never before in Italy had so many animals been depicted in attendance at a religious event. Another beautiful example of similar excess can be found in Dürer's famous *Virgin with the Animals*, executed in pen, ink and watercolour (fig. 44). Here peace reigns in the animal kingdom: the presence of Jesus has the miraculous effect of reconciling the butterfly, the snail, the dog, the beetle, the parrot, the barn owl and the screech owl, the wolf, the swans and so on. Even the flowers seem eager to participate. In this enchanted vision Dürer

Fig. 43
Titian (detail of fig. 58)

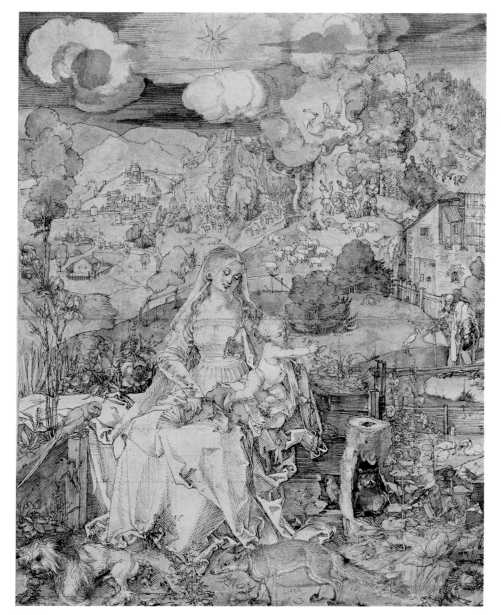

Fig. 44
Albrecht Dürer, *The Virgin with the Animals*, about 1503, Graphische Sammlung Albertina, Vienna

Fig. 45
Titian (detail of fig. 58)

displays an extraordinary ability to bring close-up details – even the most insignificant ones – into a harmonious relationship with wide, deep, open space with a distant horizon: just as Titian does in his *Flight*.

Plants and flowers represent another link between Dürer and the young Titian. The broad meadow that serves as a stage for the *Flight* is studded with all kinds of foliage as well as tall trees. The most astonishing detail is the group of plants crowned with a poppy at the lower right (fig. 45), near the fox. The freshness of this clump of vegetation is captured with exceptional painterly skill, and rendered with such spontaneity that it could be the product of a child's imagination. Vasari referred to the 'German' painters with whom Titian associated when he was planning the *Flight* as 'excellent painters of landscape scenery and plants', and indeed Dürer remains unrivalled among artists for his studies of flora. A fascinating watercolour, the *Lily of the Valley and Bugle* (fig. 46), now in the British Museum, is generally ascribed to the school or circle of Dürer, but is sometimes attributed to Dürer himself. Either way, it is datable to the period roughly corresponding to Dürer's stay in Venice. The attention paid to the slightest imperfection, the sensation that there is genuine sap running through the veins of the plants, links studies such as this (which was re-used by Dürer's workshop in a picture in the National Gallery known as the *Madonna of the Iris*) to Titian's approach to botanical subjects, and could partly explain its origins.

The curiosity aroused by Dürer in Venice was due mainly to the fame of his widely dispersed prints. These embody many aspects of the artist's approach, particularly to the animal world. For Titian it must have been extraordinary to rediscover in the metropolis art which caused him to look again at the rural world of his childhood. The prints recapitulated a series of studies and sketches made in various locations, of the kind discussed above, fixing them for all time. One of the most memorable images in this series is the engraving of the *Vision of Saint Eustace* (fig. 47). The hunting dogs in the foreground provide a real anthology of canine attitudes and characteristics. A few years

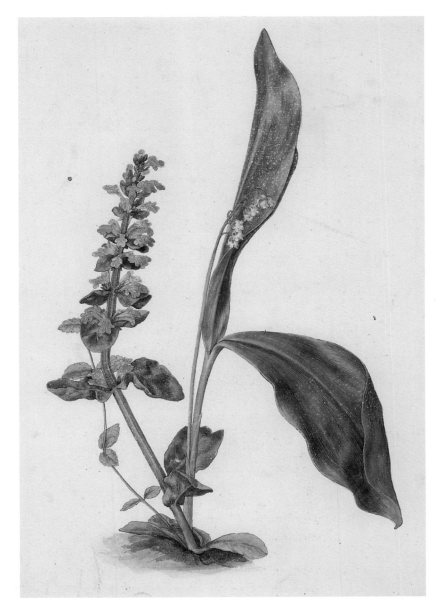

Fig. 46
Circle of Albrecht Dürer, *Two Plants (Lily of the Valley and Bugle)*, about 1502–7,
The British Museum, London

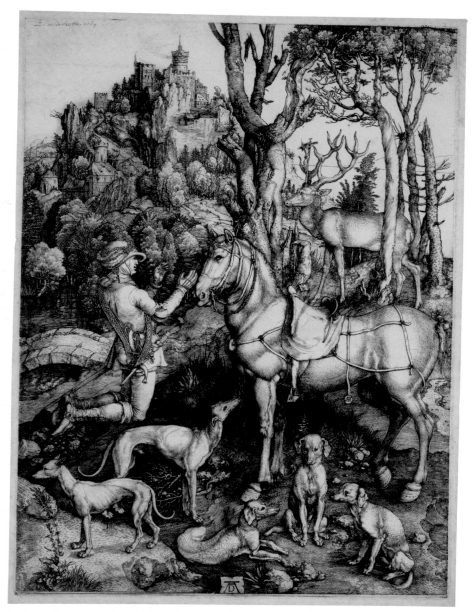

Fig. 47
Albrecht Dürer, *The Vision of Saint Eustace*, about 1500–2, The British Museum, London

later, Titian was to demonstrate that he too understood dogs: for example in his *Tobias and the Archangel* (Gallerie dell'Accademia, Venice, fig. 63) there is a white puppy at the lower left (fig. 48), a younger version of the same breed as Dürer's hounds, although Titian invests his dog with greater humanity, giving him the same ingenuous, childish expression as can be seen on the face of Tobias (see fig. 63). The muzzle of another dog (this time brown) can be spotted on Tobias' right. The body of the dog on the left is depicted with thickly applied pure white paint, and to its left a confidently painted flower reminds us that Titian himself had by now become an excellent painter of

Fig. 48
Titian (detail of fig. 63)

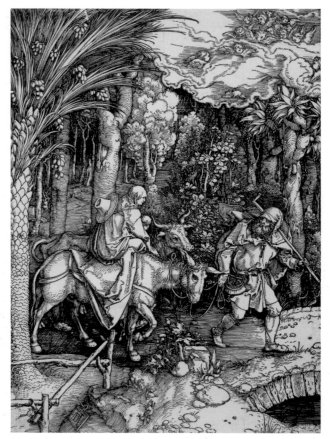

Fig. 49
Albrecht Dürer, *The Flight into Egypt*,
about 1504, The British Museum, London

Opposite:
Fig. 50
Titian (detail of fig. 58)

plants. In Dürer's print, rough vegetation pushes the horizon upwards to the top of the page and allows us fully to savour the mood and atmosphere of the forest evoked by the artist. Despite the absence of colour, it conveys an impression of every kind of greenery and vegetation.

Another print by Dürer demands our attention here, this time because of its subject and composition: his *Flight into Egypt* (fig. 49). Dürer's woodcut is designed vertically. Titian seems to have borrowed the basic composition, placing his figures frieze-like across the foreground, dense woodland providing a backdrop. In Titian's version Dürer's turning Saint Joseph is transformed into a figure who may be a wingless angel, but the dynamic between the two groups of figures is very similar (fig. 50).

Titian was not the only artist to absorb these lessons from Dürer. A fuller account of this topic than is possible here would show, for example, that both Vittore Carpaccio and Lorenzo Lotto did so in their different ways. It is worth mentioning that Lotto's altarpiece of the Assumption in Asolo Cathedral, signed and dated 1506, has at its base a predella (fig. 51) with wonderful flowers (including poppies, as in the *Flight*) and partridges in the foreground, and in the background a broad vista of the Asolan hills. If it genuinely is by Lotto (as seems likely), and if this was indeed its original format, then it must be acknowledged as the earliest painting in Italian art where landscape is the main subject.

Dürer was not the only German artist to be interested in the study of nature: the practice of Jacopo de' Barbari seems to fit perfectly into this group. Jacopo (actually a Venetian) was the author of the masterly *Bird's-eye View of Venice* (fig. 1). Very shortly after this was published in 1500, he was appointed painter at the German court of Maximilian (crowned Holy Roman Emperor a few years later), and thereafter may be considered a German artist as well as a German

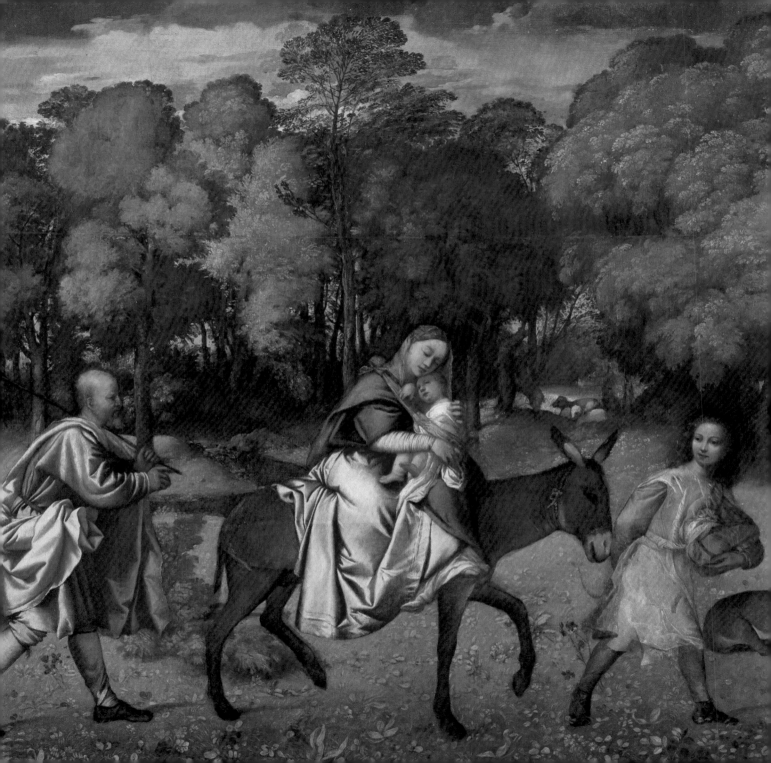

Fig. 51
Lorenzo Lotto (?), *Asolan Hills, with Flowers and Partridges in the Foreground* (detail), 1506,
Santa Maria Assunta Cathedral, Asolo

citizen. The National Gallery owns a fragment of a painting by him, a
Sparrowhawk (fig. 52) which again demonstrates how the links between
Venetian and German art around 1500 brought about a fresh vision of nature.
Like many of the animals encountered so far, the hawk is connected with the
hunt, the sport so widely practised by the artist's patrons.

Fig. 52
Jacopo de' Barbari, *A Sparrowhawk*, about 1500–10, The National Gallery, London

Titian's figures in a landscape: finding the balance

The many elements examined here show how Titian filled the canvas of his first important commission – almost to saturation point – with everything he was capable of, as if to advertise his attainments. Visually it proclaims 'I know how to paint water, skies, clouds, trees, flowers, animals, buildings and people; in other words, landscape'. But instead of catching our attention one by one, these elements are miraculously harmonised, arranged in a spatial order that is liberated from mere linear perspective. The broadening landscape and the great depth presented on the right side bring an almost symphonic dimension to the single, virtuoso elements we have been 'listening to' so far. We should not forget that Titian grew up in the mountains. Who knows how often, after his move to Venice, he returned to visit his family amongst the woods and lakes of the Cadore. Attempts were made in the nineteenth century to attach his landscapes to views in the Dolomites that surrounded him in childhood. According to John Ruskin, Titian was always attracted by the landscape of the Cadore, 'retiring to the narrow glens and forests'. The work of the painter and naturalist Josiah Gilbert, in his *Cadore: or Titian's Country*, pays moving tribute to this. Giovanni Battista Cavalcaselle made sketches in the mountains of the Cadore in order to try and identify real locations painted by Titian. These were the only sketches made by the great nineteenth-century art historian that were not taken from paintings. Earliest of all, Sir Charles Lock Eastlake, Director of the National Gallery 1855–65, made careful notes of this subject in 1830. This particular topic was not researched further in the twentieth century, but certainly deserves more attention.

Titian's landscapes are often nostalgic visions of his native land, and this aspect is certainly present in the *Flight*. In the background, on the right, an imposing Dolomite rears its head (fig. 53); a hill town at its feet is equipped with the obligatory *campanile*. The mountain Croda Cuz rises just above Pieve di Cadore, Titian's birthplace; it can be viewed from the painter's family house, and when seen from the north-east, it is superimposed on the neighbouring Sassolungo di Cibiana (fig. 54) with a profile very similar to that painted by Titian – not an exact transcription, but a fair recollection of a view which must have dominated the artist's childhood.

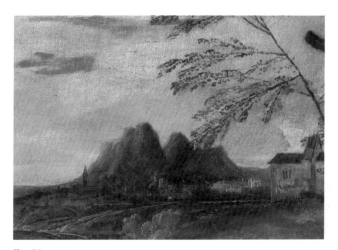

Fig. 53
Titian (detail of fig. 58)

Fig. 54
Pieve di Cadore: Mount Croda Cuz, with the Sassolungo di Cibiana behind

All considered, the animals, flowers, trees and flowing water in the *Flight into Egypt* are so typical of the Cadore that it would not be inappropriate to give the painting the alternative title of 'Flight into Cadore'. Like other high mountain regions, the Cadore is wild and harsh, recalling the words used by Paolo Pino in his *Dialogo di Pittura* in 1548 to describe the development of landscape as a genre in Northern European painting:

> 'They [Northern Europeans] imitate the lands they inhabit, which because they are so wild make a delightful picture, but we Italians live in the garden of the world, which is more delightful to see than it is to depict. Yet I have seen miraculous landscapes by Titian's hand, much more pleasing than the landscapes of Flanders'.

In Pino's opinion, it was the wild inhospitality of the surrounding countryside (he may have been thinking of the visionary landscapes of Albrecht Altdorfer) that stimulated those who lived in it to reproduce it in paint. Titian had certainly not grown up in the 'garden of the world' as his Venetian colleagues had.

It is important to remember that at this period the Cadore was a war zone: in 1508 the troops of Maximilian I (who had in the interim declared himself Holy

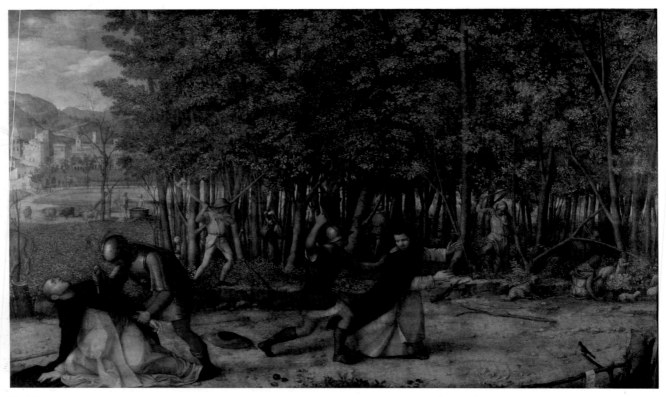

Fig. 55
Giovanni Bellini, *The Assassination of Saint Peter Martyr*, about 1506–7, The National Gallery, London

Roman Emperor) marched through the region, laying it to waste. In December that year the League of Cambrai was formed and brought Venice to the verge of collapse. Andrea Loredan, who probably commissioned the *Flight*, was personally involved in Venice's struggle for survival and was killed in battle against the army of Maximilian I in 1513. The *Flight* thus became an enchanting vision of a region that was about to be despoiled.

As we know, Giovanni Bellini was also involved in Andrea Loredan's project. According to Carlo Ridolfi's *Maraviglie dell'arte* (1648), 'In Casa Grimana in Santa Ermagora [Palazzo Loredan] he painted two great *Cosmographies* in the Great Hall, with the figures of Ptolemy, Strabo, Pliny and Pomponius Mella.

Fig. 56
Giovanni Bellini (detail of fig. 55)

Fig. 57
Titian (detail of fig. 58)

And he signed his name on it'. These Cosmographies, described in several other sources between the sixteenth and the eighteenth century, cannot now be traced, but they serve to demonstrate how a patron in search of the latest fashion in art and of youthful talent still relied on an artist described by Dürer as 'very old' but 'still the best in painting'. Bellini's painting of the *Assassination of Saint Peter Martyr* (fig. 55) can be dated to the same period as Titian's *Flight* (fig. 58). As compositions, both paintings are planned in substantially the same manner, with the chief figures disposed across the foreground as if in a frieze. The men in the middle ground carry on with their work regardless. The foliage of the trees occupies most of the top half of the composition; and on one side there is a vista onto a distant landscape. It is true that Bellini's organisation of the spatial layout is geometric, almost architectural, and belongs firmly to the fifteenth century, whereas Titian breaks up perspective planes, liberating his figures and his background, and creating a genuine fusion of the various elements.

There is no shortage of animals in Bellini's paintings, but they look somewhat 'timid', as if shy of expressing their animal strength: you only need to look at the small bird (embodying a variety of species) perched on a slender branch in the *Assassination* (fig. 56) compared with Titian's sturdy eagle (fig. 57). The relationship between these two compositions is not easy to analyse: which comes first? Perhaps we should understand the two paintings as resulting from a dialogue between the old teacher and his young pupil, a dialogue of equals – one of those rare conversations in which each party listens carefully to what the other has to say.

As we stand before Titian's imposing painting (fig. 58), we can extrapolate all sorts of qualities from the details. But in the work as a whole the inexperienced young painter has not yet managed fully to harmonise the human figures on the left within the modern landscape; they are still positioned in a traditional frieze-like manner, slightly detached from the rest. It has been noted that the subject of the *Flight into Egypt* was almost without precedent in Venice. Titian was the first artist to attempt this subject on a large scale. It seems feasible that Loredan wished to pair this painting with the *Judgement of Solomon* (fig. 8), the Old Testament premonition of the massacre of the innocents. Titian's full-scale landscape would have made a perfect counterpart to the dense architectural setting, full of classical references, in Sebastiano's painting, and

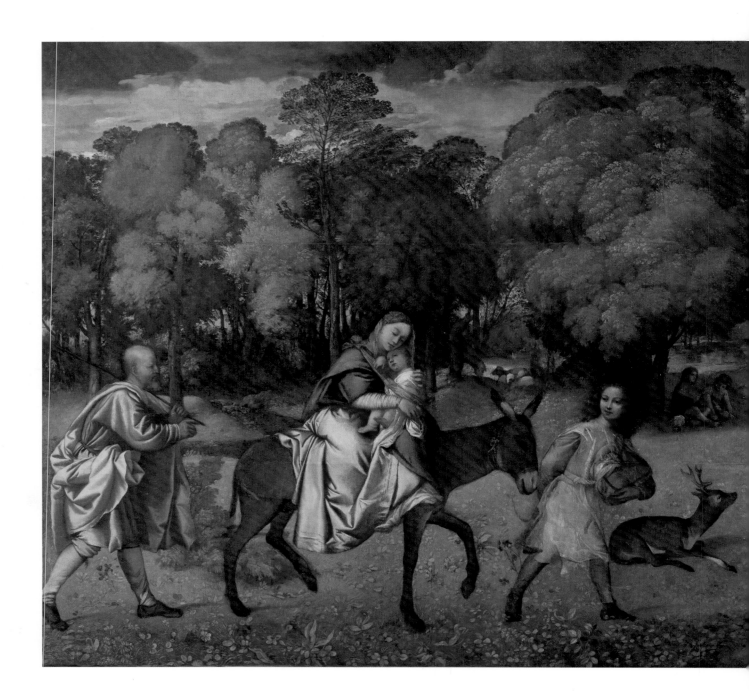

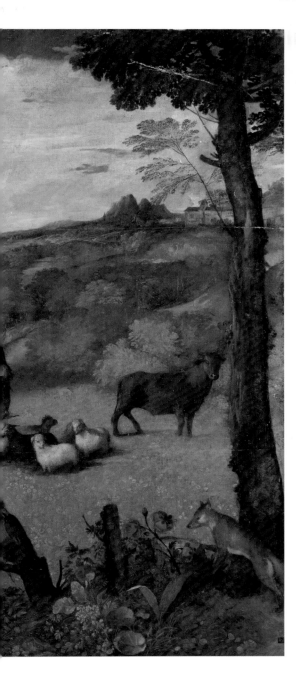

Fig. 58
Titian, *The Flight into Egypt*, about 1506–7,
The State Hermitage Museum, St Petersburg

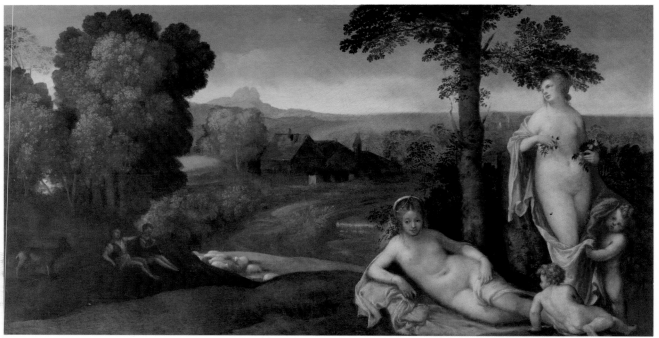

Fig. 59
Early sixteenth-century painter (Titian?),
with additions by a late sixteenth-century
Venetian (?) painter, *Nymphs and Putti in
a Landscape with Shepherds*, about 1507–8 and
about 1575 (?), The National Gallery, London
(on loan from the Victoria and Albert Museum)

it is possible that this contrast between indoor and outdoor 'visions' was conceived by Loredan himself. In the sixteenth century the Flight into Egypt became the obvious subject for anyone wishing for a 'landscape' painting. In Northern Europe, for example, it was used several times by celebrated landscape painters, from Joachim Patinir to Pieter Bruegel the Elder. In Venice its most famous exponent was Tintoretto, with his haunting visions. From the *Flight* onwards, Titian worked at perfecting the theme of 'landscape with figures', until he reached the classical equilibrium that was to become the indispensable model for his successors.

A mysterious and little-known painting in the National Gallery (fig. 59) has the emblematic title *Nymphs and Putti in a Landscape with Shepherds*. It reveals intriguing differences in style between the landscape and the figures on the right. In fact, close study of the playful putti, particularly the one showing his back, and also of some details in the female figures, suggests that they were

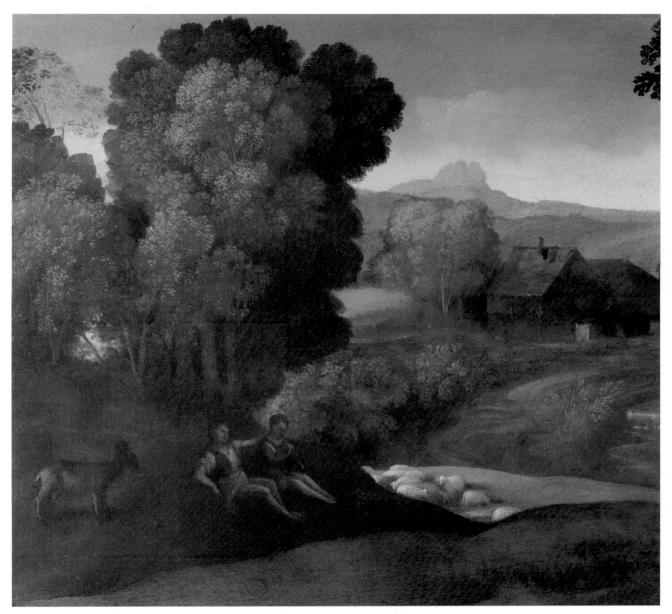

Fig. 60
Early sixteenth-century painter (Titian?) (detail of fig. 59)

Fig. 61
Titian, *Concert in a Landscape*, 1508 (?), The British Museum, London

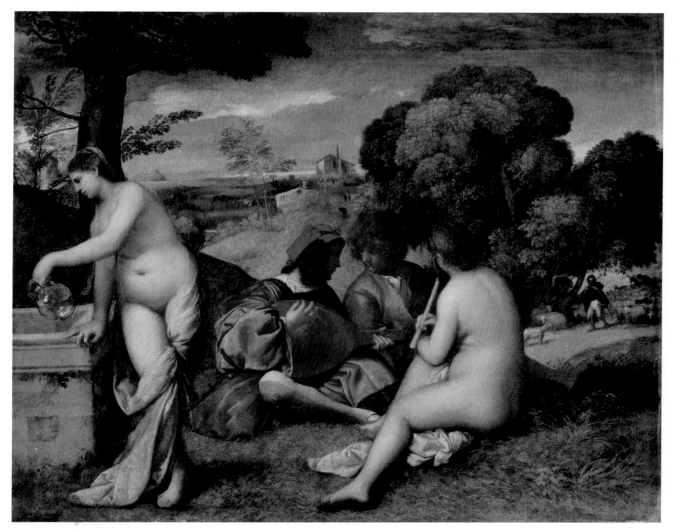

Fig. 62
Titian, *Pastoral Concert ('Concert Champêtre')*, about 1509, Musée du Louvre, Paris

painted in the late sixteenth century. The landscape on the left (fig. 60), however, is almost identical to that in a panel painting generally attributed to the young Titian (the *Birth of Adonis* in the Musei Civici, Padua). The delightful pastoral atmosphere, with two shepherds making music in the shade of the tree and the goat listening with rapt attention, and above all the painting of the foliage, vividly recalls the right-hand part of the *Flight*. Perhaps the painting was, in the words of Marcantonio Michiel, 'reconzato' (later reworked). Scientific analysis in the future may clarify the nature of the discrepancies within it.

A fine large drawing in pen and ink on paper in the British Museum (fig. 61), formerly attributed to Giorgione, is now considered by some scholars – rightly in my opinion – to be the work of the youthful Titian. The two figures stand in a landscape with dual perspectives (similar to that in the *Flight*), shaded and enclosed at the front left, with sleeping sheep and goats, light and airy in the broad landscape on the right. Variations in the colour of the ink between the male and female figures has led some scholars to suggest that these were drawn by two different hands, or at different times. It seems to me nevertheless that the intention behind the piece, and its general mood, surely belong to a single mind and hand. The female figure, seen from the side, is almost identical to the figure in the celebrated *Pastoral Concert ('Concert Champêtre')* in the Louvre (fig. 62), now almost unanimously considered to be by Titian. The male figure, stolidly occupying the available space, with his strongly juxtaposed legs and muscular arms, belongs with those figures born from a blending of Venetian and Florentine art that culminated in 1508. This was the year in which the Florentine Fra Bartolomeo was in Venice, and in which Giorgione completed his frescoes on the façade of the Fondaco dei Tedeschi (a project that was to be taken up and carried forward by Titian); this marks the first appearance of the naked human body as a central feature in a work by a Venetian artist. The sketched date 1508 on the reverse side of the page in the British Museum may therefore well be correct. Closely connected to this drawing is the painting of *Tobias and the Archangel*, referred to on page 59 (fig. 63). In this spectacular yet underestimated work the angel looks almost as if he could be the brother of the viola player in the drawing, with his dancing gait, thickset arm and downturned face. The Hungarian art historian Johannes Wilde was the first to convincingly emphasize that this painting, which bears the coat of arms of the Bembo family at its base, could be identified with one of the same subject said

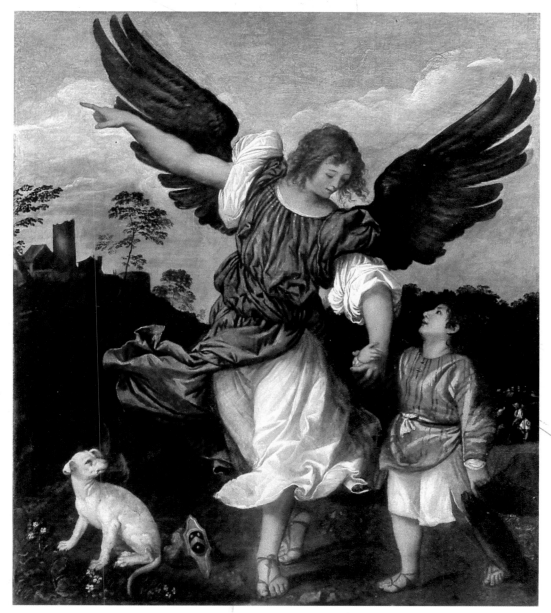

Fig. 63
Titian, *Tobias and the Archangel*, about 1508, Gallerie dell'Accademia, Venice

by Vasari to have been painted during the invasion of the Cadore by Maximilian I (and thus also in 1508). Vasari then gives the wrong description and location for the painting, confusing it with a later version of the same subject painted by a close follower of Titian, but this does not alter the main contention.

Another painting that may be connected with the London drawing is the *Rest on the Flight into Egypt* at Longleat House (fig. 64). Here too figures and landscape interact, the Holy Family being placed in the shade of a tree. Christ's exhausted parents sink wearily down, the Virgin's flowing cloak draped over a rock; Saint Joseph propping himself on a natural outcrop of roots and earth and closing his eyes, panting. The monumental figure of the Virgin prefigures other Titian heroines such as his *Judith as Justice,* the fresco formerly above the Merceria entrance to the Fondaco dei Tedeschi; or Mary Magdalene in his later *Noli me Tangere* (fig. 69) – both wear a transparent veil. Saint Joseph (fig. 66) is an older, more exhausted and less decisive counterpart to the same figure in the *Flight*, identically dressed in dark plum and orange-yellow (fig. 65). By this stage, Titian had evidently already learned to match his 'modern' vision of landscape with an equally 'modern' rendering of the human figure.

This brings us naturally to the *Holy Family with a Shepherd* in the National Gallery (fig. 68). The figures here occupy almost all the pictorial space; the sole function of the landscape, admirable though it may be, is to crown the sculptural group in the foreground. Mary and Joseph are clothed in the same harmonious colours: blue and red, dark plum and orange. Compared with the Longleat painting, however, the figures are weightier, and we perceive the weight via various other elements such as the staff driven into the ground by Saint Joseph and the hand of the kneeling shepherd: propped on the rock, it acts as a pivot. A comparable painting by Titian, generally dated to around 1510, can be found in the Sacristy of the Church of Santa Maria della Salute; Saint Mark here enthroned, looks like a close relation of Saint Joseph. In the National Gallery painting the integration between man and nature is almost complete. The figures, and especially the faces, strike us as painted from living models – like the animals but unlike the sacred figures in the *Flight* (fig. 67). Titian's practice as a portrait painter, which certainly entailed painting as distinct from merely drawing his sitter, perhaps influenced his subject paintings.

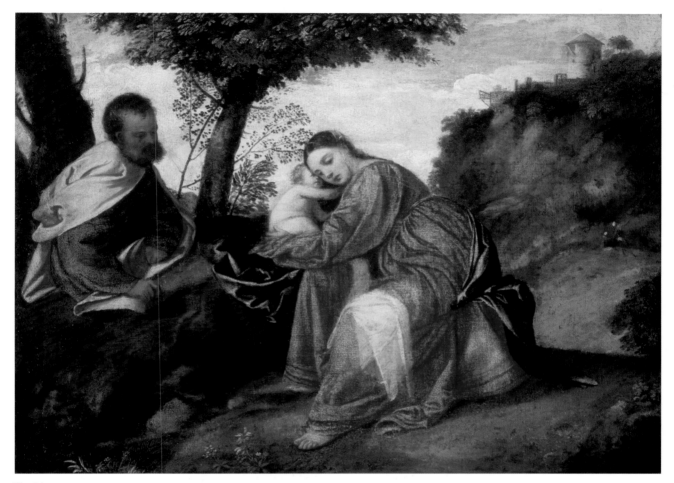

Fig. 64
Titian, *Rest on the Flight into Egypt*, about 1508–9, The Most Hon. the Marquess of Bath, Longleat House, Warminster, Wiltshire

Fig. 65
Titian (detail of fig. 58)

Fig. 66
Titian (detail of fig. 64)

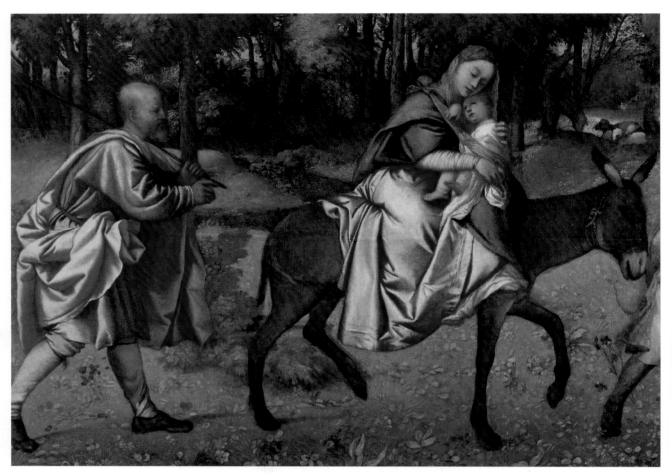

Fig. 67
Titian (detail of fig. 58)

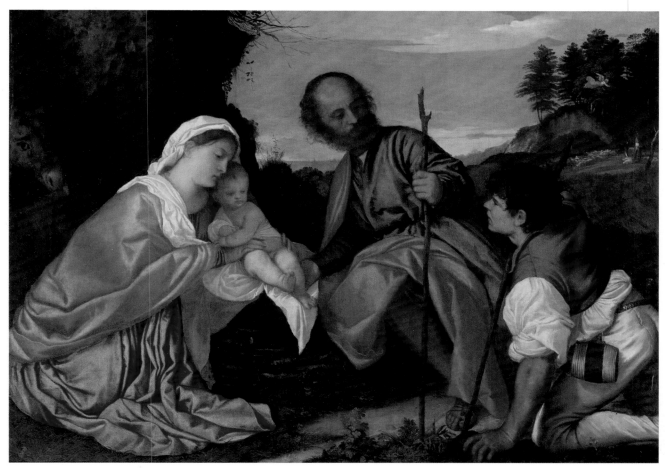

Fig. 68
Titian, *Holy Family with a Shepherd*, about 1510, The National Gallery, London

Reaching maturity: *Noli me Tangere*

The culmination of this study of Titian's early career is his small yet monumental *Noli me Tangere* in the National Gallery (fig. 69), depicting the moment when Mary Magdalene, having found Christ's tomb empty, recognises her risen Lord. This work represents the full maturing of Titian's classic style, achieved through his work on the frescoes in the Scuola del Santo in Padua, completed in 1511. The *Noli me Tangere* is thus to the genre of figures in a landscape what '*La Schiavona*' (fig. 14) is to the portrait. Here we sense Titian's pleasure in portraying man in a natural environment, achieving a perfect balance between figures and a landscape. Titian's greatest achievement in this respect is the celebrated *Death of Saint Peter Martyr*, painted in the late 1520s for the Venetian church of San Zanipolo, unfortunately lost in a fire. The two human figures in the *Noli me Tangere* seem to be performing a balletic dance on a 'stage' positioned in the very foreground. Titian is able to integrate figures and background by using very subtle juxtapositions of lines. The composition essentially describes a large 'X': the 'legs' are the figures of Christ and Mary Magdalene, the 'arms' the tree and the outline of the mountain peak on the right. The farm buildings are bathed in early morning light, accompanied by a gentle breeze typical of sunrise in springtime; the breeze stirs the grass and lifts the drapery in the foreground. The stone building reflects the first rays of the rising sun (p. 29) and it is impossible not to recall the tower kissed by rays of dawn in Bellini's *Agony in the Garden* (fig. 17). In only a few years, Titian had successfully developed the seeds of this genre born in fifteenth-century Venice, raising it to the European canon. His paintings convey a genuinely living natural world that pulsates afresh every time our eye lights upon it.

Fig. 69
Titian, *Noli me Tangere*, about 1511–12, The National Gallery, London

List of exhibited works

No. 1 (fig. 14)

Titian, *Portrait of a Lady ('La Schiavona')*, about 1511, oil on canvas, 119.4 x 96.5 cm, The National Gallery, London, inv. NG 5385

No. 2 (figs 6–7)

Titian, *Portrait of a Man (a Barbarigo?)*, about 1512–4, oil on canvas, 79 x 63 cm, Collection of the Duke of Northumberland, Alnwick Castle, inv. 03349

No. 3 (fig. 5)

Titian, *Portrait of Gerolamo (?) Barbarigo*, about 1509, oil on canvas, 81.2 x 66.3 cm, The National Gallery, London, inv. NG 1944

No. 4 (fig. 4)

Titian, *Portrait of a Man*, about 1507–8, oil on canvas, 75 x 62 cm, Ickworth, The Bristol Collection (acquired through the National Land Fund and transferred to the National Trust in 1956), inv. ICK/P/74/851770

No. 5 (fig. 13)

Sebastiano del Piombo, *Salome*, 1510, oil on wood, 54.9 x 44.5 cm, The National Gallery, London, inv. NG 2493

No. 6 (fig. 10)

Sebastiano del Piombo, *Head of a Girl*, about 1506–7, oil on wood, 33.6 x 28.5 cm, The Faringdon Collection Trust, Buscot Park, Oxfordshire, England, inv. 48

No. 7 (fig. 18)

Giovanni Bellini, *The Madonna of the Meadow*, about 1495–1500, oil and egg on synthetic panel, transferred from wood, 67.3 x 86.4 cm, The National Gallery, London, inv. NG 599

No. 8 (fig. 23)

Circle of Giovannino de' Grassi, *Two Wolves*, about 1400, watercolour and bodycolour on vellum, 16 x 12.1 cm, The Trustees of the British Museum, London, inv. 1895,1214.95

No. 9 (figs 21–22)

Giorgione, or his circle, *Homage to a Poet*, about 1495–1500, oil on wood, 59.7 x 48.9 cm, The National Gallery, London, inv. NG 1173

No. 10 (fig. 25)

Giulio Campagnola, *Stag at Rest chained to a Tree*, about 1505–10, engraving with stipple, 18.2 x 11.8 cm, The Trustees of the British Museum, London, inv. 1845,0825.775

No. 11 (figs 26–27)

Giorgione, *The Adoration of the Kings*, about 1498–1500, oil on wood, 29.8 x 81.3 cm, The National Gallery, London, inv. NG 1160

No. 12 (fig. 30)

Giorgione, *The Virgin and Child in a Landscape*, about 1500, oil on canvas, transferred from wooden panel, 44 x 36.5 cm, The State Hermitage Museum, St Petersburg, inv. GE 185

No. 13 (fig. 29)

Follower of Martin Schongauer, *The Virgin and Child in a Landscape*, about 1480–90, oil on lime, 30.2 x 21.9 cm, The National Gallery, London, inv. NG 723

No. 14 (fig. 38)

Titian (?), *Holy Family in a Landscape*, about 1506 (?), oil on canvas, transferred from wooden panel, 47.5 x 39.5 cm, The State Hermitage Museum, St Petersburg, inv. GE 230

No. 15 (figs 32, 33 and 35)

Giorgione, *Il Tramonto (The Sunset)*, about 1501–2, oil on canvas, 73.3 x 91.4 cm, The National Gallery, London, inv. NG 6307

No. 16 (fig. 49)

Albrecht Dürer, *The Flight into Egypt*, about 1504, woodcut, 29.5 x 20.8 cm, The Trustees of the British Museum, London, inv. 1895,0122.634

No. 17 (fig. 47)

Albrecht Dürer, *The Vision of Saint Eustace*, about 1500–2, engraving, 36.1 x 26.2 cm, The Trustees of the British Museum, London, inv. 1868,0822.183

No. 18 (fig. 40)

Albrecht Dürer, *Studies of a Hare*, about 1500–2, pen and ink on paper, 12.6 x 22 cm, The Trustees of the British Museum, London, inv. SL,5218.157

No. 19 (fig. 41)

Albrecht Dürer, *Study of a European Bison, standing in profile to left, looking to front*, about 1501–4, pen and black ink on paper, 21.3 x 26 cm, The Trustees of the British Museum, London, inv. SL,5261.101 (verso)

No. 20 (fig. 52)

Jacopo de' Barbari, *A Sparrowhawk*, about 1500–10, oil on oak, 17.8 x 10.8 cm, The National Gallery, London, inv. NG 3088

No 21 (fig. 46)

Circle of Albrecht Dürer, *Two Plants (Lily of the Valley and Bugle)*, about 1502–7, brush drawing in watercolour on paper, 25.7 x 17.5 cm, The Trustees of the British Museum, London, inv. 1895,0915.986

No. 22 (figs 12, 19, 20, 24, 28, 34, 36, 42–43, 50, 53, 57–58, 65, 67)

Titian, *The Flight into Egypt*, about 1506–7, oil on canvas, 204 x 324.5 cm, excluding the later addition of c. 10 cm to the right-hand edge, The State Hermitage Museum, St Petersburg, inv. GE 245

No. 23 (fig. 55–56)

Giovanni Bellini, *The Assassination of Saint Peter Martyr*, about 1506–7, oil and tempera on wood, 99.7 x 165.1 cm, The National Gallery, London, inv. NG 812

No. 24 (figs 59–60)

Early sixteenth-century painter (Titian?), with additions by a late sixteenth-century Venetian (?) painter, *Nymphs and Putti in a Landscape with Shepherds*, about 1507–8 and about 1575 (?), oil on wood, 46.6 x 87.6 cm, The National Gallery, London (on loan from the Victoria and Albert Museum, inv. 341-1878)

No. 25 (fig. 61)

Titian, *Concert in a Landscape*, 1508 (?), pen and brown ink, over black chalk, on paper, 22.3 x 22.6 cm, The Trustees of the British Museum, London, inv. 1895,0915.817

No. 26 (figs 64, 66)

Titian, *Rest on the Flight into Egypt*, about 1508–9, oil on canvas, 46.4 x 63 cm, The Most Hon. the Marquess of Bath, Longleat House, Warminster, Wiltshire, inv. 9550

No. 27 (fig. 68)

Titian, *Holy Family with a Shepherd*, about 1510, oil on canvas, 99.1 x 139.1 cm, The National Gallery, London, inv. NG 4

No. 28 (fig. 69)

Titian, *Noli me Tangere*, about 1511–12, oil on canvas, 110.5 x 91.9 cm, The National Gallery, London, inv. NG 270

Acknowledgements

I am deeply grateful to Nicholas Penny, who gave me the unique opportunity to work on this project, and who so generously assisted in every aspect of putting together this exhibition and book.

My supervisor Giovanni Agosti has nurtured my passion for the history of art, and Jennifer Fletcher has shared with me her great knowledge of Titian and sixteenth-century Venice. The lenders to the exhibition, in particular Irina Artemieva at the Hermitage, and Hugo Chapman and Giulia Bartrum at the British Museum, were extremely generous in sharing their research and knowledge with me. Francis Russell helped me in finding the Buscot Park painting. I am also grateful to Federica D'Amico for accompanying me in my search for Titian's mountains in the Dolomites.

Almost every department at the National Gallery has provided some form of support to this project. It would be impossible to name everyone, but a few individuals deserve special thanks. Carol Plazzotta, Arturo Galansino, and Susan Foister have provided fundamental support and encouragement at every stage. Catherine Putz, Francesca Sidhu, Eloise Stewart and Stephen Dunn were indispensable in coordinating the many processes and people involved in staging the exhibition. Nicola Freeman rendered my research accessible to the general public, Willa Beckett helped in the search for sponsorship for the exhibition, and Elspeth Hector and all the library staff were assiduous in helping me track down vital reading matter. Larry Keith and Rachel Billinge offered invaluable insight into conservation practices and methods of analysis, while Britta New's careful restoration work, Peter Schade's sensitive integration of new frames, and Chris Oberon's shrewd exhibition design have helped make the show both historically sensitive and visually beautiful.

Last but not least, I am deeply grateful to the National Gallery Company, who understood the nature of the project and helped transform my ideas into a wonderful book. In particular I would like to thank Rachel Giles, Jan Green, Rosalind McKever and Jane Hyne. Joe Ewart, whose design brought the publication together so beautifully, also deserves a special mention.

Antonio Mazzotta

This exhibition has been made possible by the provision of insurance through the Government Indemnity Scheme. The National Gallery would like to thank HM Government for providing Government Indemnity and the Department for Culture, Media and Sport and Arts Council England for arranging the indemnity.

Further reading

The National Gallery's paintings by Titian after 1540 are catalogued by N. Penny in *National Gallery Catalogues: The Sixteenth Century Italian Paintings: Volume II: Venice 1540–1600*, London 2008 pp. 200–311.

The two standard monographs and *catalogues raisonnés* on the artist are: R. Pallucchini, *Tiziano*, 2 vols, Florence 1969 and H. Wethey, *The Paintings of Titian: Complete Edition*, 3 vols, London 1969–75.

Useful accounts of Titian's early chronology are provided by: J. Wilde, *Venetian Art from Bellini to Titian*, Oxford 1974 (particularly pp. 94–120); A. Ballarin, 'Tiziano prima del Fondaco dei Tedeschi', in *Tiziano e Venezia: Convegno internazionale di studi: Venezia, 1976*, Vicenza 1980, pp. 493–9; A. Ballarin, 'Le problème des œuvres de la jeunesse de Titien: Avancées et reculs de la critique', in *Le siècle de Titien: L'âge d'or de la peinture à Venise*, eds M. Laclotte and G. Nepi Scirè, exh. cat., Grand Palais, Paris 1993, pp. 357–67.

On the history and function of Titian's *Flight into Egypt*
I. Artemieva, 'New light on Titian's "Flight into Egypt" in the Hermitage', *The Burlington Magazine*, CLIV (2012), pp. 4–11.
P. Joannides, *Titian to 1518: The Assumption of Genius*, New Haven and London 2001, pp. 35–49.

On iconography of the *Flight into Egypt* in general
B.L. Brown, 'Travellers on the Rocky Road to Paradise: Jacopo Bassano's *Flight into Egypt*', *Artibus et historiae*, 64, XXXII (2011), pp. 193–219.
M. Tanzi, in *Il Rinascimento nelle terre ticinesi: Da Bramantino a Bernardino Luini*, eds G. Agosti, J. Stoppa and M. Tanzi, exh. cat., Pinacoteca Züst, Rancate and Musei civici, Sala Veratti, Varese, Milan 2010, n. 33, pp. 144–51.

On Titian's early patrons (in particular Andrea Loredan) and their portraits
I. Artemieva, 'La *Fuga in Egitto* dell'Ermitage', in *Tiziano: Restauri, tecniche, programmi, prospettive*, ed. G. Pavanello, Venice 2005, pp. 3–15 (especially pp. 14–15).
M. Hirst, *Sebastiano del Piombo*, Oxford, 1981, pp. 12–23.
M. Gemin and F. Pedrocco, *Ca' Vendramin Calergi*, Milan 1990.
R. Martinis, 'Ca' Loredan-Vendramin-Calergi a Venezia: Mauro Codussi e il palazzo di Andrea Loredan', *Annali di architettura*, 10–11 (1998–9), pp. 43–61.
R. Martinis, 'Su un fregio all'antica. Un'ipotesi per Antonio Lombardo nel palazzo di Andrea Loredan a Venezia', *Arte Veneta*, LVI (2000), pp. 16–37.
A. Mazzotta, 'A "gentiluomo da Ca' Barbarigo" by Titian in the National Gallery, London', *The Burlington Magazine*, CLIV (2012), pp. 12–19.
H. Wethey, *The Paintings of Titian*, London 1971, vol. II.

On Giorgione and Schongauer
W. Suida, 'Spigolature giorgionesche', *Arte Veneta*, VIII (1954), pp. 153–66 (especially pp. 153–5).

On Dürer and the animal world
W.M. Conway (ed. and trans.), *The Writings of Albrecht Dürer*, ed. and trans., New York 1958.
C. Eisler, *Dürer's animals*, Washington and London 1991.

On Titian and early landscape painting in Italy
F. Algarotti, *Saggio sopra la pittura*, Livorno 1763 (revised edn Venice 1784), p. 73.
J. Fletcher, 'Figuras en el paisaje en las obras de Tiziano del Museo del Prado', in J. Álvarez Lopera et al., *Tiziano y el legado veneciano*, Barcelona 2005, pp. 191–204.
A. Morassi, 'Esordi di Tiziano', *Arte Veneta*, VIII (1954), pp. 178–98.

Photographic credits

P. Pino, *Dialogo di pittura*, [1548], eds R. and A. Pallucchini, Venice 1946, p. 145.

J. Ruskin, *The Works of John Ruskin*, eds E.T. Cook and A. Wedderburn, London 1904, vol. V (*Modern Painters* vol. III), pp. 397–8.

E. Tietze-Conrat, 'Titian as a Landscape Painter', *Gazette des Beaux-Arts*, XLV (1955), pp. 11–20.

On the development of landscape painting in Italy and Europe

R. Buscaroli, *La pittura di paesaggio in Italia*, Bologna 1935 (especially pp.159–98).

K. Clark, *Landscape into Art*, London 1949.

E.H. Gombrich, 'The Renaissance Theory of Art and the Rise of Landscape', in E.H. Gombrich, *Norm and Form: Studies in the Art of the Renaissance*, London and New York 1966 (2nd edn 1971), pp. 107–121.

G. Romano, *Studi sul paesaggio: Storia e immagini*, Turin 1978 (2nd edn 1991).

C.S. Wood, *Albrecht Altdorfer and the Origins of Landscape*, London 1993.

On Titian and the Cadore

S. Avery-Quash (ed.), 'The Travel Notebooks of Sir Charles Eastlake', *The Walpole Society*, LXXIII (2011), vol. 1, pp. 86–7.

J. Gilbert, *Cadore: or Titian's Country*, London 1869.

This book was published to mark the exhibition
Titian's First Masterpiece: The Flight into Egypt

Held in the Sunley Room at the National Gallery, London
4 April–19 August 2012

First published in Great Britain in 2012 by
National Gallery Company Limited
St Vincent House, 30 Orange Street
London WC2H 7HH

www.nationalgallery.co.uk

ISBN: 978 1 85709 544 9
1033829

Translated by Caroline Beamish

British Library Cataloguing-in-Publication Data.
A catalogue record is available from the British Library.
Library of Congress Control Number: 2012931184

Project Editor Rachel Giles
Editor Jan Green
Picture Researcher Rosalind McKever
Production Jane Hyne and Penny Le Tissier
Designer Joe Ewart for Society

Reproduction by DL Repro, London
Printed in the United Kingdom by Principal Colour

All measurements give height before width

All images of *The Flight into Egypt* in this book exclude
the later c. 10 cm strip added to the right-hand edge.

Front cover:
Titian, *The Flight into Egypt* (detail), about 1506–7,
The State Hermitage Museum, St Petersburg

Page 2:
Titian, *The Flight into Egypt* (detail), about 1506–7,
The State Hermitage Museum, St Petersburg

Page 4:
Titian, *The Flight into Egypt* (detail), about 1506–7,
The State Hermitage Museum, St Petersburg

Page 10:
Titian, *Portrait of Gerolamo (?) Barbarigo* (detail), about 1509,
The National Gallery, London

Page 11:
Titian, *Portrait of a Lady ('La Schiavona')* (detail), about 1511,
The National Gallery, London

Page 28:
Giovanni Bellini, *The Madonna of the Meadow* (detail),
about 1495–1500,
The National Gallery, London

Page 29:
Titian, *Noli me Tangere* (detail), about 1511–12,
The National Gallery, London